IMAGES
of America

BIG MEADOWS AND LAKE ALMANOR

IMAGES
of America

BIG MEADOWS AND
LAKE ALMANOR

Marilyn Morris Quadrio

ARCADIA
PUBLISHING

Published by Arcadia Publishing
Charleston, South Carolina

Printed in the United States of America

Library of Congress Control Number: 2014934540

For all general information, please contact Arcadia Publishing:
Telephone 843-853-2070
Fax 843-853-0044
E-mail sales@arcadiapublishing.com
For customer service and orders:
Toll-Free 1-888-313-2665

Visit us on the Internet at www.arcadiapublishing.com

This history is dedicated to my friend of over 50 years, Joan Bayles Sayre. She has been my partner in numerous adventures and follies, including the founding of the Chester–Lake Almanor Museum, and has been relentless in pushing me forward with this project. I would also like to thank teaching buddy John Goolsby, who refused the loan of another book until I had written my own, and lastly, my history-loving friend Marti Leicester, who showed me how it could be done.

CONTENTS

ACKNOWLEDGMENTS

Over the past 30 years, so many people have gifted the Chester–Lake Almanor Museum with pieces of the past, bits of family lore, ancestral photographs, and tales of hardship, celebration, and true grit, that it would be impossible to name them all here. We are eternally grateful for their generous gifts, including the hardworking crew of volunteers, whose gift of time helped us put it all together and staff it for years. We treasure each and every one of you; many of you are now valued friends.

Unless otherwise noted in the caption, all photographs in this volume are the property of the Chester–Lake Almanor Museum.

INTRODUCTION

On a beautiful fall Saturday in September 1973, two elderly ladies intent on a nostalgic trip down memory lane crashed an E Clampus Vitus event on the west shore of Lake Almanor. Cousins Genevieve Pratt Hodgson and Helen Sommer Gage were granddaughters of Willard Pratt, the founder of the original town of Prattville. The Clampers are an organization of lodges founded following the Gold Rush to celebrate the forty-niner era of California; the celebrations often involving boisterous partying.

On that particular Saturday, the local Plumas County lodge, from Quincy, was paying tribute to the first village in what had once been Big Meadows. The damming of the North Fork of the Feather River, completed by 1914, had flooded the meadows, destroying the town, homes, and ranches of a number of pioneer settlers as well as a number of native Maidu Indian villages. After learning the identities of the two ladies, the Clampers made them the honored guests for the day. The two soon found themselves seated in an antique fire truck, escorted by a brass band as part of a short, but noisy, parade around the Almanor Inn neighborhood. Later, a delegation of Clampers rowed out onto the lake to drop a ceremonial brass plaque honoring Prattville and its residents displaced by the construction of the Almanor Dam by the Great Western Power Company.

Big Meadows, Na'kam Koyo in Maidu, was an oddly shaped meadow nearly bisected by a tree-lined ridge, now the Lake Almanor Peninsula. Nearly 30,000 acres, the meadows were approximately 20 miles in length, 4 to 5 miles wide, and covered in lush grasses, tules, and willows. The meadows were watered by the North Fork of the Feather River; Benner, Johnson, Last Chance, and Bailey Creeks; the Hamilton Branch; and a great number of springs. Among these were Pratt, Bunnell, and Abbott Springs, along with the largest spring in the state, Big Springs.

These meadows appeared a paradise to the parched emigrants traveling the 1848 Lassen Trail, after their toil through the dry stretches of the Nevada desert and Modoc and Lassen Counties. The trail entered very near Big Springs, where they were welcomed with an abundance of water and grasses as high as their horses' bellies. They also found a plentiful supply of fish, deer, and geese to fill their bellies while they cut grasses and filled the water barrels, preparing for the last, long, dry haul down the ridges to the Sacramento Valley. Some would remember this well-watered oasis when experiencing the long, dry, hot summers of the great Central Valley. Certainly, Peter Lassen remembered.

In the late 1850s, two young Indian Valley newcomers—Nathaniel "N.B." Forgay and John Colt—had a team of oxen that required shoeing and some wagon wheels and plow blades in need of a blacksmith's attention. As there was no blacksmith in Indian Valley at that time, the pair chained the wheels to the ox team's harness and made their way to Big Meadows where a smithy, James Underwood, had set up a shop in the lower end near the bridge. While spending the night, the blacksmith told the young men that old Peter Lassen was in the woods nearby, falling and skinning logs to construct a cabin, and he needed help skidding the logs to the building site. Once the oxen were shod, the pair set out to find Lassen and succeeded in skidding the logs for

his cabin. When Forgay related this story to Augustus "Gus" Bidwell and other witnesses in the early 1900s, he told the men that he and a friend returned to Big Meadows late that fall on a fishing and goose hunting expedition and found the finished cabin sitting abandoned. Inquiries brought the news that Lassen had only lived in the cabin briefly before packing up and leaving for the Honey Lake Valley. The cabin, which housed several different occupants over time, was part of the dairy on the Blunt ranch and, later, a home for a Maidu family; however, it was abandoned after the roof collapsed under a heavy snow. After Bidwell telling this story to the Westwood Auto Club at a meeting in 1926, members brought trucks up to the site the next day and removed the remaining logs to the Bidwell property in Greenville. Gus and his son Bruce Bidwell then hauled the logs to Oroville where they were donated to the Pioneer Museum.

This cabin was built by Peter Lassen in the lower end of Big Meadows some time in the later 1850s. Indian Valley residents N.B. Forgay and John Colt skidded the logs for Lassen with their ox team. Returning months later to duck hunt, they found the cabin finished but deserted and learned that Lassen had returned to the Honey Lake area after a brief stay in Big Meadows. (Courtesy of California State University, Chico, Meriam Library Special Collections.)

One

FIRST PEOPLE MEET THE INCOMING TIDE

The sudden appearance of white strangers must have startled the native inhabitants of Nakam Koyo. Anthropologists speculate that there may have been as many as 10 small villages of 5 to 10 cone-shaped shelters or *hubos*. A *hubo* (or *hubu*) was built of branches and bark slabs leaning against poles tied together above a fire pit. Dirt would be piled against the base and sides to help hold the wood covering in place, as well as insulate the structure. Inside would be beds of deer or bearskins, with woven rabbit skin blankets, laid on cedar or pine boughs around the fire pit.

These villages were scattered around the perimeter of the meadows, in the tree line for shade and shelter and close to a water source. A village would also have a *k'um*, a large beamed, round, earth-covered structure used for dances, ceremonies, and as a sweat lodge. It might also be used as a winter dwelling for a number of families to share during the long, cold winters.

This land was generous in food sources, both in wild game and plants. Called derogatively "digger Indians" for their use of digging sticks, the California tribes were settled hunters and gatherers rather than nomads. They had learned to tend and harvest a variety of bulbs, tubers, and roots, including wild carrots and onions; camas; purple, white, and golden brodiaea; cattails; and tules. They gathered all manner of seeds and berries, the most important being the acorns of certain oaks. The acorn nuts were ground, and the flour then leached of its tannic acid in a labor-intensive process. The flour could be cooked as mush, plain or with berries and other additives, or as patties, baked on the hot rocks near the fire.

Tribes had learned which plants and trees offered medicines for common ailments; which were best for the construction of tools and hunting equipment like bows, arrows, and spears; and which to tend for the best growth of basket-, net-, and rope-weaving materials. The natives, in their hundreds of years here, had learned to live well entirely on the resources available to them; skills which very few white people recognized for their value. Many pioneers did recognize the beauty of the unique handwoven Maidu baskets and traded for them or were gifted baskets by the native women who formed relationships with the settlers.

When first faced with the influx of white strangers, the generally peaceful Maidu responded with cautious, wary tolerance. This tolerance was not always reciprocated by the white men. One Lassen Trail party reported arriving in the meadow to find a dugout canoe floating on Big Springs with two Maidu men who had been shot dead while fishing. Within a few short years, the Maidu people would find their way of life increasingly disrupted, with the men forced to work for white

ranchers and the women pressed into service as laundry maids and child minders. Unfortunately, exposure to white settlers included exposure to many new diseases, and many natives succumbed to measles, chicken pox, influenzas, and tuberculosis. As the number of whites increased, the population of native Maidu steadily decreased.

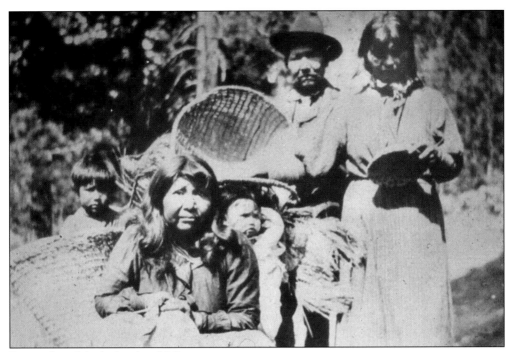

Pictured is a Maidu family—Nellie, Betsy and Fred Thomas—in Humbug Valley. Andrew Miller first acquired land in Humbug in 1859, and he and his family were known to have close friendly relationships with the local Maidu people. (Courtesy of the Miller family.)

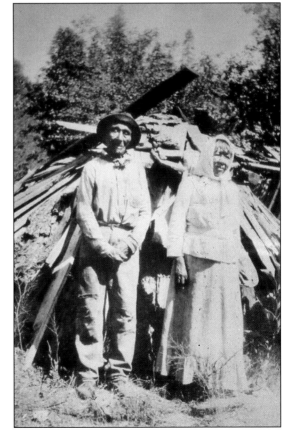

This is an image of an older Maidu couple in front of a traditional *hubo* (or *hubu*) made of cedar bark slabs. It had a fire pit in the center, with pine bough beds covered with skins, including woven rabbit-skin blankets. In good weather, most daily living chores would have been done outdoors.

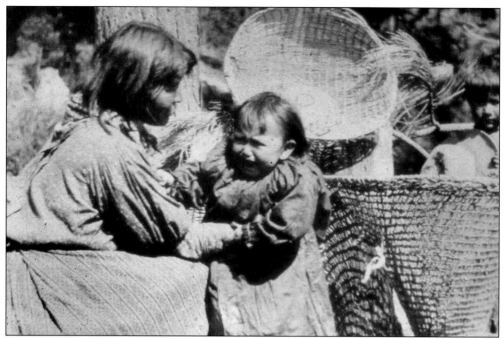

Pictured here are Nellie Thomas and children with a variety of baskets made to suit different purposes. Whether for sweeping seed heads of plants into gathering baskets, use as storage baskets, winnowing baskets, or woven cradleboards, they were vital to fulfilling the most basic needs of food storage and preparation, in addition to having beautiful forms and designs.

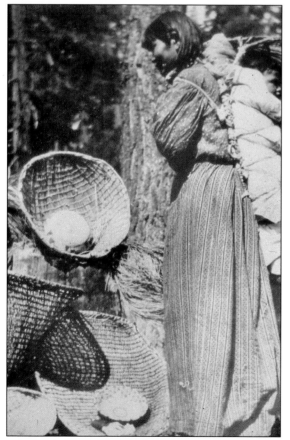

This is another image of Nellie Thomas with child. The cradleboard allowed mothers to easily take their babies everywhere with them, suspended on their backs or leaned against a convenient tree. It was an important child-minding tool, keeping baby safe while mother was cooking, for example.

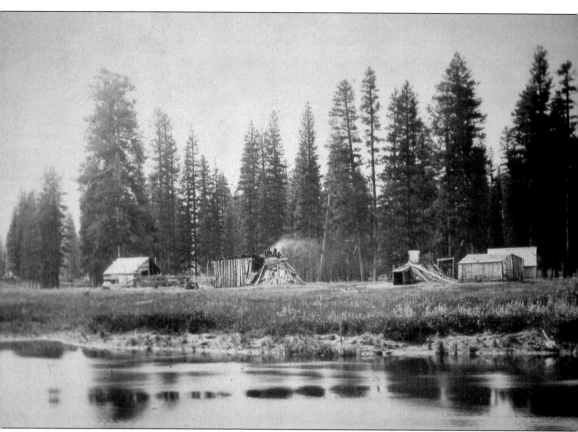

Here is a Maidu Indian encampment in Big Meadows. Many local settlers, as well as tourists, visited this camp, located one-half mile north of Prattville, to purchase or trade for animal skins, baskets, and other collectibles. Baskets were often given as gifts to white women by the Maidu women who worked for them.

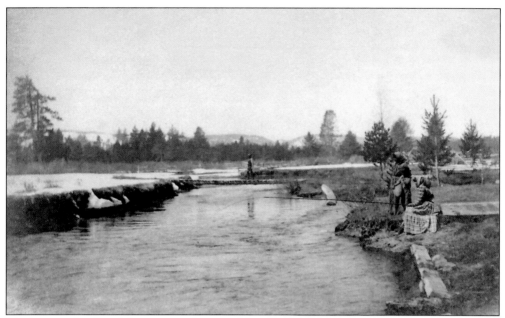

Maidu were the first fishermen in the area. Here are Upper Big Meadows residents Kate and Lucy Charley fishing near the site of present-day Chester. Fish, like strips of deer meat and other meat sources, could be dried or smoked and stored for the lean winter months. (Courtesy of the Evens family.)

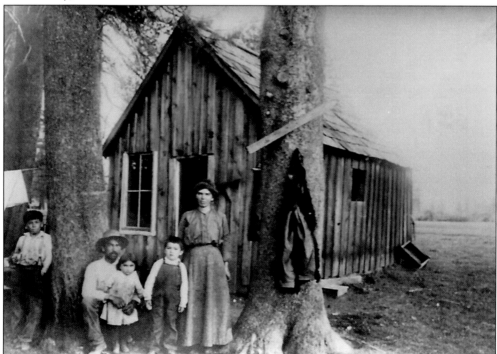

In this image is the Harvey and Annie Williams family near Chester. The small girl is Lucy Williams Patterson. Local Maidu men worked on the ranches, becoming expert ranch hands and mastering trades like blacksmithing. (Courtesy of the Evens family.)

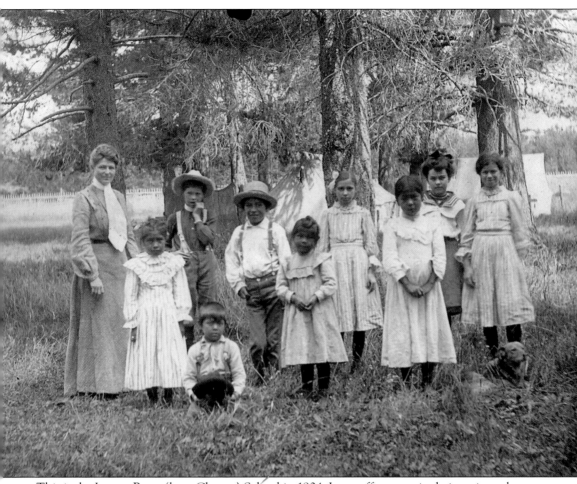

This is the Lassen Butte (later Chester) School in 1904. In an effort to strip their native culture from them and acculturate them into white culture, many Plumas County Maidu children were taken from their parents and sent to boarding schools as far away as the Carlisle Indian Industrial School in Carlisle, Pennsylvania, or as close as the Indian school in nearby Greenville. However, Big Meadows Maidu children were welcome in the local schools. (From the George Olsen Album; courtesy of David Nopel.)

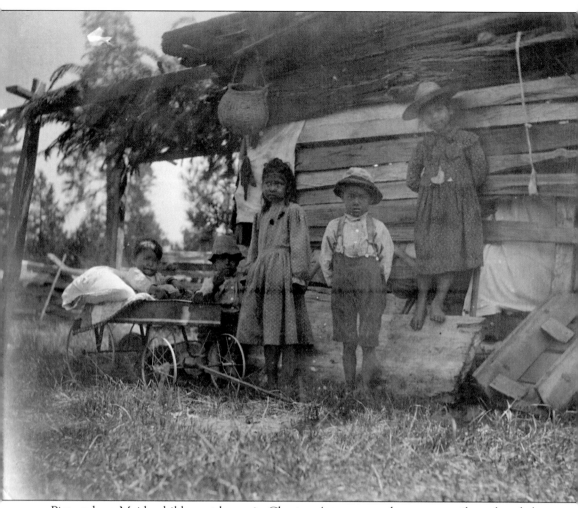

Pictured are Maidu children at home in Chester. A toy wagon has temporarily replaced the cradleboard. Traditional mothers still sometimes use cradleboards with infants to this day. The small fir bough–covered structure to the left resembles an arbor many California tribes built to provide shade for their outdoor work and living areas. (From the George Olsen Album; courtesy of David Nopel.)

Two

BUTT VALLEY

The first major impact of the influx of hundreds of gold seekers, both white and Chinese, was felt by the early 1850s. Having prospected at Bidwell Bar and in the lower Feather River Canyon, the men trailed up the North Fork and then began following the streams that fed the river up the narrow, steep ravines, from settlements like Cariboo (Caribou), into the high country of Butt Valley (named for early miner Horace Butt), Humbug Valley, and Big Meadows. A large number of strikes in the Seneca area drew hundreds of miners to that locale, in a region that became the Seneca Township of Plumas County in 1854.

The first prospector to discover gold in Seneca was David Kirkham, a farmer from Marion County, Missouri, who arrived in California in 1850 or 1851 and struck gold in the North Fork canyon as early as 1852. The resulting settlement now known as Seneca was for most of the late 1800s known as Marion Flat and so listed in the early voter registers for Plumas County. Kirkham is variously listed as a miner, a farmer, a store clerk, and a blacksmith, not to mention his tenure as first justice of the peace for Seneca Township in 1859 and 1860.

Miners' requirements for food and other supplies brought opportunities for early merchants, like partners Luther "Lute" Wellington Bunnell and James Lee. The pair had arrived in California together in June 1851 and, following largely unsuccessful mining adventures at the appropriately named Poorman's Creek and Rich Bar, decided more money could be made supplying the miners than in mining. Like fellow merchants, they brought pack trains up from Marysville and other Sacramento Valley commercial centers. Shortly, the partners had stores in Cariboo and Butt Valley and with a third partner—Henry Landt—operated a ranch raising cattle and hogs. James Lee's wife, Julia, arrived in early 1854 with her sister Lena Ann "Laney" Smith. Laney married William Miller, and together they built a hotel and ranch in Butt Valley, which, with the store, a saloon, and blacksmith, formed a tiny village in the small valley (2,080 acres). John McBeth, who had arrived in Plumas County in 1850, acquired 600 acres for a dairy ranch in the upper end of Butt Valley, which his brother James ran. John moved to Greenville, serving as postmaster and Wells Fargo agent while still operating a sawmill in Butt Valley and, in 1876, a mercantile business with J.D. Compton in Greenville. John's son Horace, born in Butt Valley in 1872, settled in Quincy, where he succeeded his father as county treasurer in 1899.

James Lee's son Charles, born in Plumas County in 1855, and Charles's wife, Eva Costar Lee, later acquired the McBeth Ranch. Charles was the heir to his Aunt Lena's Butt Valley hotel

and ranch, which he operated for her after the death of Lena's husband, William Miller, in 1879. Lena lived with Charles and Eva until her death in 1904. By that time, the Lees had sold all their holdings in Butt Valley and Big Meadows to the Great Western Power Company, gaining enough money to purchase most of Warner Valley, above Chester.

Charles Lee's parents, Julia and James Lee, had moved up to Big Meadows in 1861, where James died in 1864. Widow Julia married her late husband's partner, Luther Wellington Bunnell, in 1869. Bunnell had accumulated 940 acres in Big Meadows, near the base of the ridge now called the Peninsula. Off the point of today's Peninsula, Lute and Julia built a large hotel, the Bunnell, which became a highly desired destination for the crowds of summer visitors to Big Meadows in the 1880s and 1890s.

New York native William Miller (1833–1879) came to California in 1852 and mined on the Feather River until 1858, when he went into ranching, first in Humbug and then Butt Valley. He died relatively early, leaving wife Lena Ann ("Laney") to run the Butt Valley Hotel and the family ranch with the help of nephew Charles Lee Sr. (Courtesy of Plumas County Museum.)

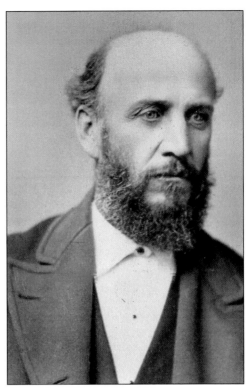

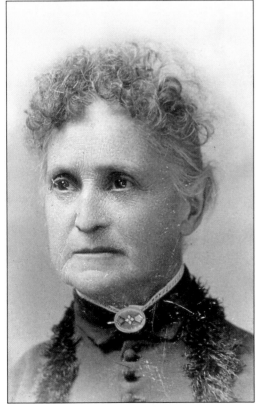

Lena Ann "Laney" Smith Miller came to Plumas County from her native New York with her sister Julia Lee in 1854. The pair of young women enjoyed a busy social life in an area with so few ladies. With husband William, she helped establish a small community in Butt Valley. (Courtesy of Plumas County Museum.)

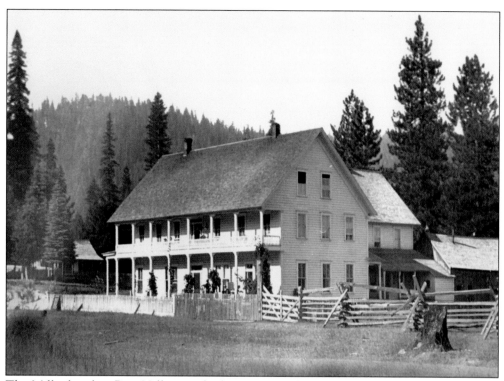

The Miller hotel in Butt Valley was built in 1879 in the southern end of the valley. When built, it was on a major trade route up from the Feather River Canyon through Cariboo to Big Meadows, with branches leading to Marion Flat (now Seneca) and Humbug Valley. (Courtesy of Plumas County Museum.)

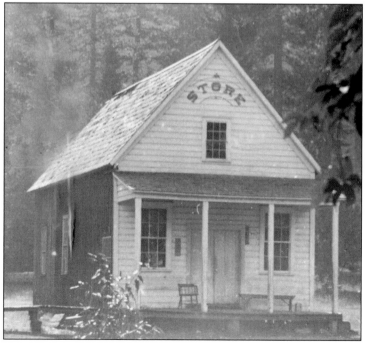

The Butt Valley Store, established by James Lee, Lute Bunnell, and William Miller, sat across from the hotel, with a saloon and a blacksmith's shop nearby. (Courtesy of Plumas County Museum.)

John "Johnny" McBeth, along with his brother James, operated a cattle and dairy ranch in the northern end of Butt Valley as well as a sawmill. He also opened a mercantile business in Greenville and became the Plumas County treasurer, a position filled by his son Horace following Johnny's death in 1899. (Courtesy of Plumas County Museum.)

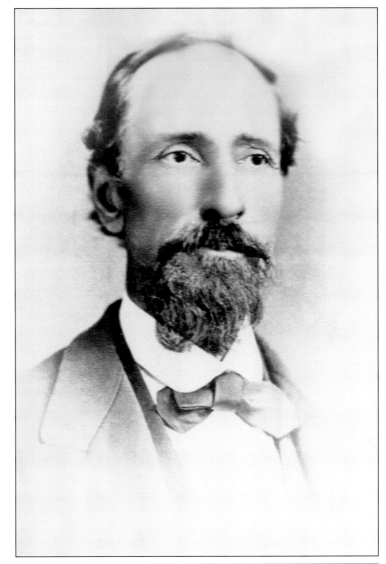

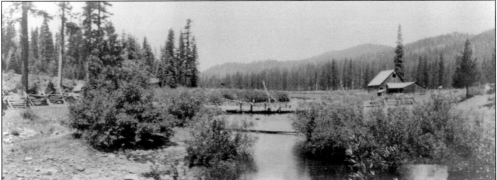

Labeled simply "View from the Bridge Butt Valley," this Lee family photograph may be of the Lee/McBeth ranch.

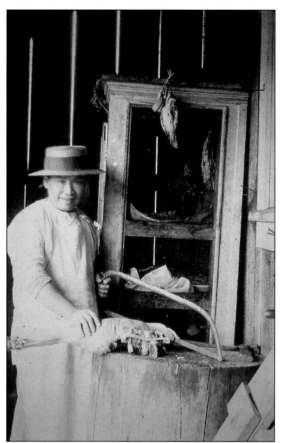

This is a Lee family photograph of the Lees' Chinese cook, Gee Foon, cutting meat for a meal in the ranch's slaughterhouse. As mining opportunities for the Chinese dwindled, most left the area, but a handful remained to work as house servants.

This is an image of the Butt Valley Hotel burning about 1922. After the completion of work on the Butt Lake dam, Great Western Power Company burned nearly all the buildings in the valley, just as they did at Big Meadows.

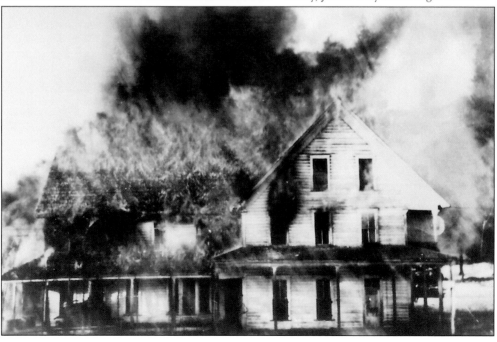

Three

THE EAST SIDE

The earliest settler in Big Meadows was Joshua Abbott, who had built a cabin near the site of the town of Prattville in 1855. In 1860, he moved over to Abbott Springs on the west side. By 1873, he decided the meadows were becoming too crowded, sold his ranch to Floriana Dotta, and moved to Modoc County, where at age 75 he stated he could "grow up with the country."

Gold miner Abbott was the first of a steady trickle of settlers who came to take up ranches in Big Meadows in the second half of the 1850s. Pack trails were being replaced with rudimentary roads from Greenville and Quincy through Haun Meadows and what would become the Humbug Road from Oroville through Dogtown (now Magalia) to Humbug Valley and Big Meadows. The first mail delivery to the Big Meadows vicinity was to a wooden box nailed to a tree at the Corner Place (a US Post Office designated drop off site), where the Humbug and Humboldt Roads, as well as a third trail, came together. Henry Landt served as the postmaster. Samuel Knight and Ned St. Felix built the first bridge over the North Fork in the southern end of the meadows and received a license to collect tolls in 1854. The bridge would later be replaced, and tolls were then collected by the Bidwells, operating from their conveniently located Meadow View Hotel, built near the river on the Greenville Prattville Road.

Among those 1850s settlers were the Hamilton and Holmes families, the first ranchers to settle permanently in Big Meadows rather than just use the meadows for summer pasturage. John Thomas Hamilton had arrived in California via the new Beckwourth trail in the early 1850s. An incredibly lucky young man, John had gotten lost from one wagon train while out hunting, and after wandering lost for three or four days, he found another train of wagons, which allowed him to join and complete his journey with nothing more than his rifle and horse. Making his way over the mountains into Genesee Valley, he found his way to a trading post near the site of Greenville. It was there he met Sarah Holmes, newly arrived from Missouri.

They married on August 12, 1856, and moved to the eastern side of Big Meadows, settling on a ranch of 400 acres on the stream that now bears their name. Loving the view of Lassen Peak across the meadow, John built the first primitive log cabin with the doorway facing the view. Their first daughter, Marietta, was born in the cabin on December 13, 1857, the first white child born in Big Meadows. Five more daughters and a son would follow. John worked hard splitting rails to fence part of his land, building a milk house across the creek from the house and adding barns, a chicken coop, and a large garden area, all while tending to the horses, cows, and hogs.

Following the pattern of nearly all the early ranchers, John skimmed the cream from his cows' milk and churned it into butter to sell to mining communities and larger settlements like Chico and Red Bluff. He built a large wood shop where in winter butter kegs, known as firkins, were made from white fir; these kegs did not impact the flavor of the butter.

John's wife, Sarah, was the second daughter of Isaac and Elizabeth Holmes, who had left their home in Missouri with their large family in 1853. Eldest daughter Rebecca had fallen in love with a fellow emigrant, James S. Becraft, and they married before the wagons left Missouri. Rebecca gave birth to their first child, William P. Becraft, in July 1854, the second white child born in Indian Valley, where Rebecca and James settled to farm. Father Isaac Holmes and family followed John Hamilton and Sarah to Big Meadows, settling on 320 acres just south of and adjoining the Hamilton ranch. When Isaac died in 1868, widow Elizabeth ran the Holmes ranch with the help of her 18-year-old twin sons: Abram (also known as "Ab") and Aaron. Following Elizabeth's death in 1872, Ab became head of the Holmes ranch and purchased the Daniel and Lucinda Blunt ranch just to the south. After Ab's death in 1901, his widow, Birdie Noble Holmes, and her sons sold the ranch to Great Western Power Company and moved to Susanville.

Sarah Hamilton lost her spouse, John, in 1878, leaving her with their seven children, from 22-year-old Marietta to 4-year-old namesake Sarah "Sari" Josephine. With some hired help, and no doubt help from her neighboring Holmes brothers, she continued to run the ranch. In earlier days, Sarah would take the children out in good weather to the shade of a large pine on a ridge behind the ranch. There with their dog Tige, she would sit to do handwork and watch for raiding Indians—the "Mill Creeks" (Yahi tribe), who periodically made raids on the native Maidu, stealing and enslaving young girls and, it was rumored, white children, if they could. This was a real threat; in 1866, Mill Creeks had raided a Maidu village in Big Meadows, killing six Maidu and taking captives. In Butte County, raids by small bands in 1862 and 1863 had resulted in the deaths of several white settlers and children.

Sarah turned her energies into running the ranch. Her eldest daughter, Marietta, had fallen in love with cousin John T. Becraft, and they married in July 1883. John and Marietta settled on the home place and helped run the ranch they later took over when Sarah died in 1892. They raised son Clarence and five daughters—Grace, Frankie, Thelma, Gretta, and Pearl—on the ranch, until it was sold to Great Western Power Company and flooded in 1914. Moving first to Indian Valley, they found their ranch there being overrun with slag and tailings from Englemine. The mine bought out this property, and the Becrafts settled permanently in Sacramento in 1918.

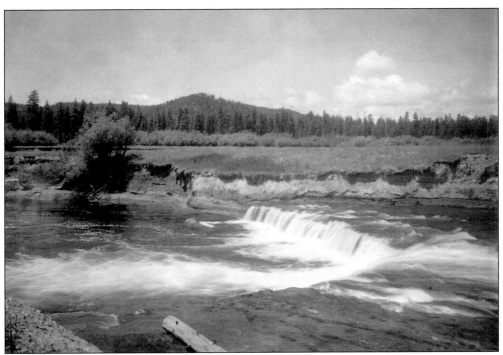

A cascade is created on the Feather River in the southern end of Big Meadows after the meeting of the western branch and Hamilton Branch (eastern branch) of the North Fork.

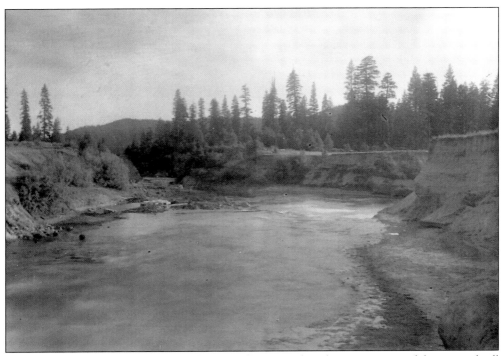

In the river, near the center left, can be seen a low stone foundation, remains of the original toll bridge built in 1854 by Samuel Knight and Ned St. Felix that was supplanted by a metal bridge.

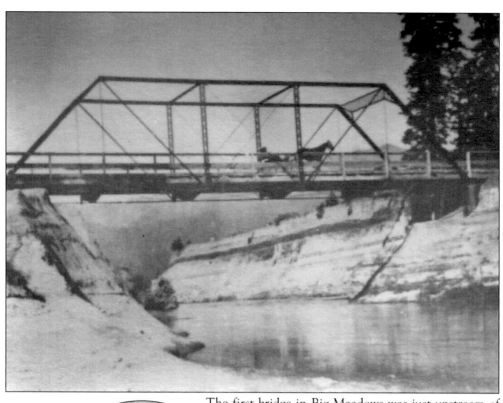

The first bridge in Big Meadows was just upstream of this iron bridge. The rushing river had cut a deep channel before plunging down the gorge leading to Seneca and the Feather River Canyon. This bridge was the crossing for the original road up from Indian Valley, today's Old Haun Road. The present-day Wolf Creek section of Highway 89 was constructed and became the main road during the dam construction between 1910 and 1914.

This gentleman is John T. Hamilton, an early pioneer rancher on the Hamilton Branch side of Big Meadows. This adventurous Virginian claimed 400 acres with his new bride, Sarah, in 1856, beginning the dairying era in the meadows.

Sarah Holmes Hamilton came to California with her parents in 1853. Her father and mother would take up 320 acres adjoining Sarah and John's ranch on the Hamilton Branch. Sarah would raise six strong, self-sufficient daughters and one son, John E. Hamilton.

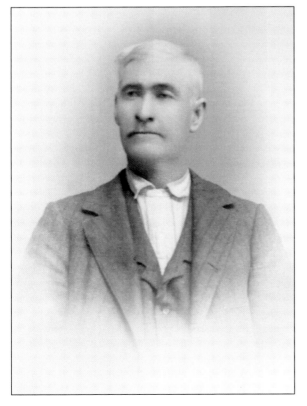

Ab Holmes, Sarah's younger brother, took over the running of the Holmes ranch after his father Isaac's death in 1868. After his mother's death in 1872, he purchased the Blunt place just to the south, the site of Peter Lassen's cabin. (Courtesy of Plumas County Museum.)

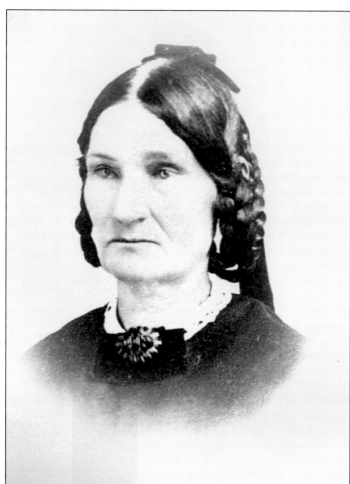

Elizabeth Holmes had journeyed with her husband, Isaac, from their farm in Indiana to Missouri and then on to California in 1853. She would give birth to and raise 11 children—5 daughters and 6 sons—including twins Abram and Aaron, who were only three during the crossing to California. Elizabeth died in 1872 and now rests next to Isaac in the Prattville cemetery. (Courtesy of Plumas County Museum.)

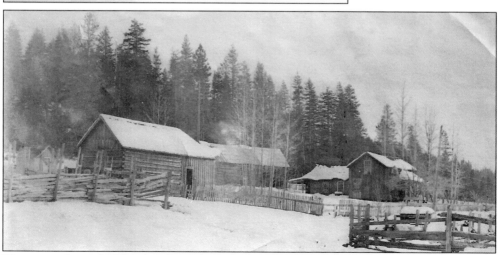

This image shows the Hamilton/Becraft ranch in winter. As one of the families who wintered in, they had to harvest enough hay and lay in enough food supplies to last them, and their animals, through a winter of unpredictable length.

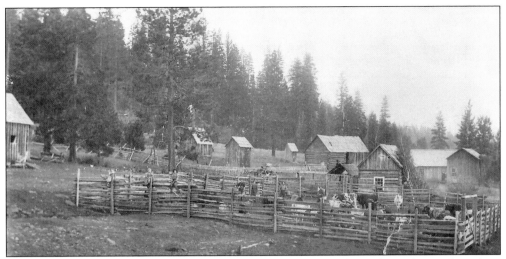

This image shows men with pails in their hands at the Hamilton/Becraft ranch corral, ready to begin a milking of the herd, which were probably Durham crosses. The modern dairy breeds of Holstein, Jersey, and Guernsey had not yet arrived in the mountains of California. The tree-lined ridge behind the ranch house is now lined by homes along East Shore Highway 147.

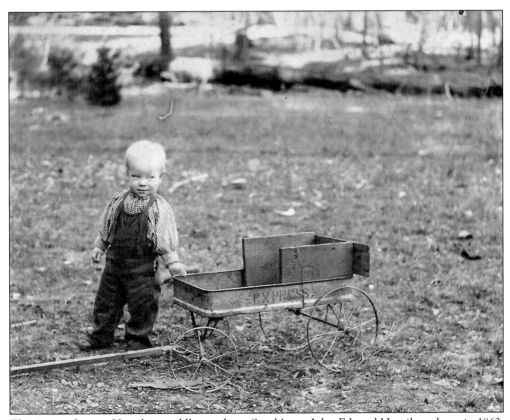

This image shows a Hamilton toddler, perhaps Sarah's son John Edward Hamilton, born in 1862, with his "Express" wagon.

John E. Hamilton is pictured here, all grown up. His oldest sister and brother-in-law had inherited the home place. John and many other members of the Hamilton and Holmes families moved to the foothills of Shasta County near Millville, where the climate was milder.

Seen here is Rebecca Holmes Becraft, Sarah's older sister, who settled in Indian Valley with her husband, James S. Becraft, in 1853.

James S. Becraft, husband of Rebecca and father of John T. Becraft, who, with cousin and wife Marietta, took over the running of the Hamilton ranch when Marietta's mother, Sarah, died in 1892.

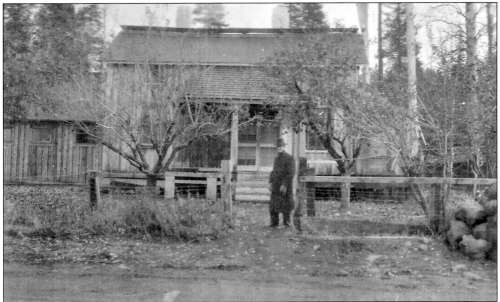

This is the Becraft home on the ranch, with John T. Becraft in the gateway. A loving father of six and hardworking man, John T. was named after his uncle John T. Hamilton. John Becraft and wife Marietta Hamilton Becraft inherited the ranch founded by Marietta's father, John T. Hamilton.

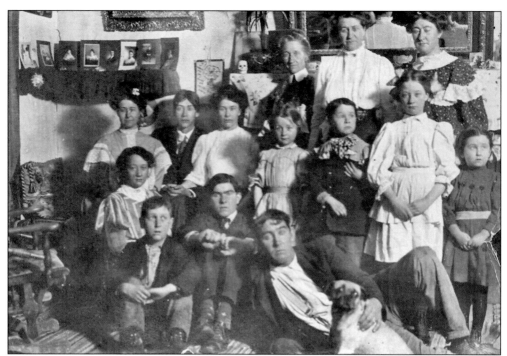

In this photograph taken in a family parlor are the daughters of John and Sarah Hamilton with some of their husbands and children. From left to right, (first row) Frankie Becraft (kneeling), Wallace Powers, Walter Powers, and Fred Webb with dog; (second row) Martha Ellen Hamilton Thatcher, Charles Overmeyer, Amy Hamilton Overmeyer, Thelma Becraft, Leonard Thatcher, Gretta Becraft, and Amy Webb; (standing) sisters Marietta Hamilton Becraft, Ada Hamilton Powers, and Sarah J. Hamilton Webb.

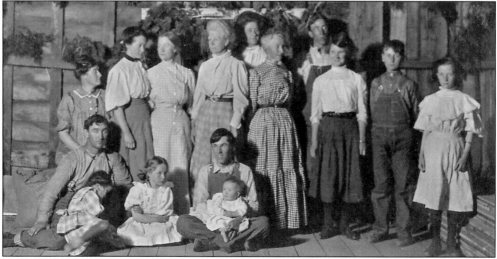

Shown in this image taken in the ranch workshop are, from left to right, (sitting on floor) Fred Webb with daughter Amy Webb (reacting to the flash powder), Thelma Becraft, and Charles Overmeyer with baby daughter Edith; (second row) Sarah J. Hamilton Webb (sitting), Frankie Becraft, Grace Becraft, unidentified, Ada Hamilton Powers, Marietta Hamilton Becraft, unidentified, Alta Fay Powers, Wallace Powers, and Gretta Becraft.

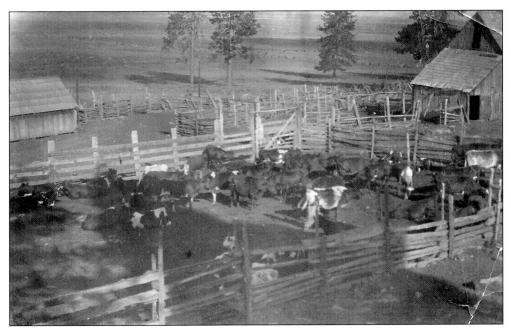

This image of the milking in the Becraft corral shows the sweeping view of Big Meadows in the background.

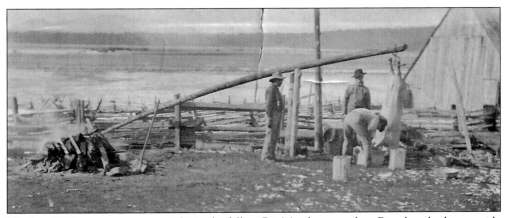

Hog butchering was a common sight in the fall on Big Meadows ranches. Ranchers had to provide their own bacon and hams. The meat would be smoked in a smokehouse, while some parts would be ground for sausage.

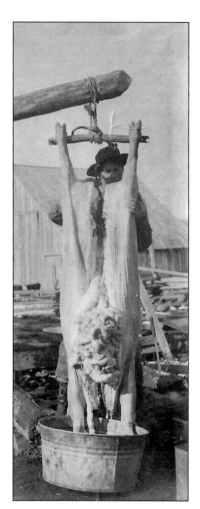

Hog butchering continues with the intestines being removed so they could be cleaned and washed for use as sausage casings. The hog fat would be rendered for lard to be used for cooking and soap making.

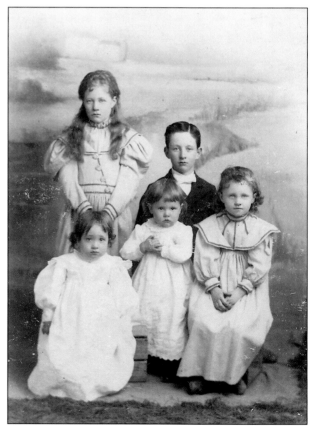

These are the children of Marietta and John T. Becraft. From left to right are (first row) little cousin Olive Hamilton and sisters Frankie and Pearl Becraft; (second row) Grace and Clarence Becraft.

This is Pearl Becraft's Sunday school attendance report from 1898. The Becrafts had strong family ties to Indian Valley and sometimes boarded there for the children's school and church attendance.

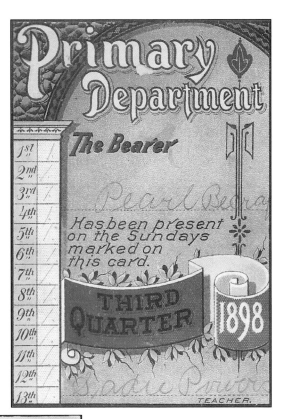

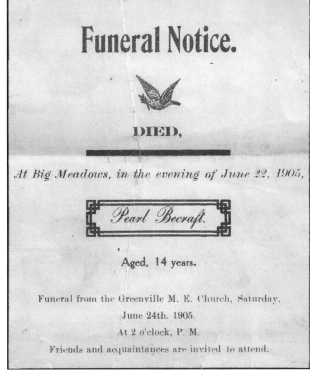

Pearl Becraft had spent most of her childhood as a semi-invalid due to a heart condition. Her mother would school her at home when necessary. In 1905, her heart gave out, and the family lost a beloved daughter and sister.

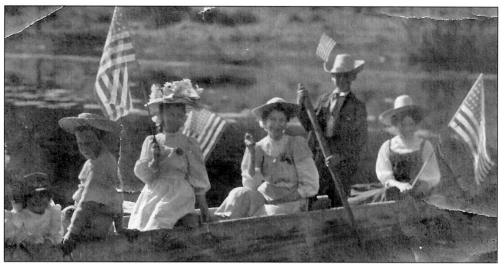

In a lighter moment, Marietta takes her children out in a dugout canoe on Big Springs on the Fourth of July, the biggest holiday of the year.

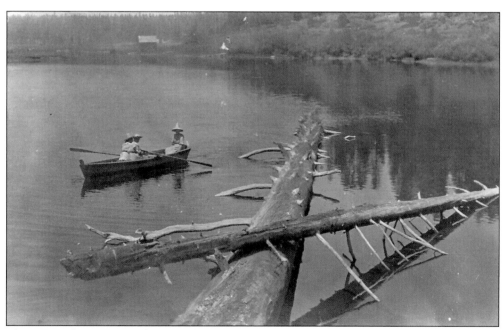

These Becraft women are about to take to the waters of Big Springs in a rowboat built by resident Big Meadows boatbuilder George Butterfield. This photograph indicates the sheer size of Big Springs—the largest natural spring in the state.

Marietta (seated) is pictured with her daughters, from left to right, Grace, Gretta, Frankie, and Thelma at their home in Indian Valley after leaving Big Meadows.

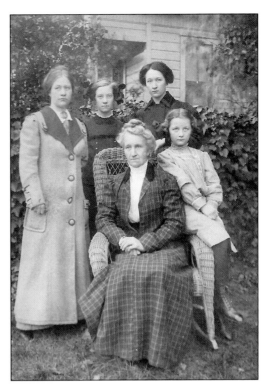

This image shows the county bridge over the Hamilton branch. The stream is a lasting memorial to three generations of a pioneer family that made their home here. (Courtesy of Plumas County Museum.)

This is Elsie Bidwell in her summer kitchen in the southern end of Big Meadows. An outdoor screened kitchen acts as a good solution for cooking meals on a hot wood range during the summer months.

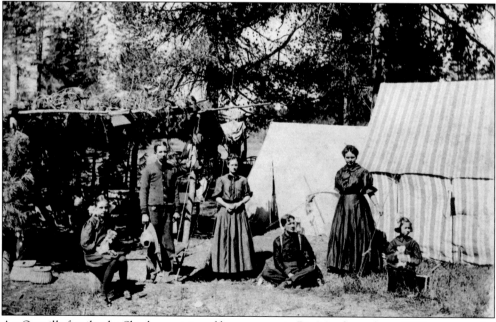

An Oroville family, the Sharkeys, pictured here, camps in Big Meadows about 1900 to escape the valley heat. The girls have brought their teddy bears, and the men are well equipped to enjoy the legendary fishing. (Courtesy of Plumas County Museum.)

Four

HUMBUG VALLEY

Humbug Valley, originally known as Soda Valley for the number of soda springs, also saw an influx of miners and settlers in the 1850s. The original community of Longville was named for William B. Long, who crossed the plains in 1854 and took up grazing land in Humbug with partner B.K. Ervine in 1855. Long and his family moved to the Honey Lake Valley in 1862, but he continued to graze cattle in Humbug during the summers. Gold was discovered in Humbug, and mining began in earnest by 1857. By 1859, two hundred miners were working claims, adding to the population in the small valley. Eli Walleck, with a partner named Jones, built a water-powered sawmill at the lower end of the valley and became one of the major freighters to the mining settlements. Walleck was notorious among the ladies for the language he used with his teams; one claimed his swearing "would make a government mule skinner blush!" She would drag her young girls into their cabin as soon as he was in earshot.

William Long partnered with Allen Wood to build the first hotel in 1858, the nucleus for the small hamlet of Longville that grew up along the trail that became Humbug Road. That first hotel burned in 1859 but was rebuilt in 1860. The second hotel burned in 1871, and a third was built to replace it below the small ridge that still features the Victorian-style home of the Andrew Miller family.

Andrew Miller, an immigrant from Bavaria, had passed through Humbug Valley in 1849 or 1850 and returned later to settle, opening a mercantile business. He became the first postmaster in 1860 and, later, a Plumas County supervisor from 1860 to 1866. He was appointed receiver of the US Land Office in Susanville, California, in 1874, after which his family lived part-time in Susanville. The family was still often in Humbug, especially in summer. After Miller died in 1903, most of his land holdings were sold to Oro Light and Power, but his family kept enough land to build the landmark house in 1909. Andrew's son Frank rocked-in one of the valley's soda springs in 1903. It has continued to draw visitors for its carbonation and medicinal properties, just as the quiet beauty of Humbug Valley has remained popular with summer campers and visitors.

Longville remained small, with a store, post office, saloon, hotels, and two sawmills serving the small population of miners and ranchers, as well as the summer tourists from Oroville, Chico, and other points in the Sacramento Valley. Plummer Welch had erected a steam sawmill in the 1860s at the north end, as well as establishing a dairy and stock ranch and owned the last large hotel in the valley. The hotel burned in early August 1904, resulting in the deaths of two small children: a son of the Keith Miller family and the daughter of a waitress.

Henry Landt, a partner of Luther Wellington Bunnell and James Lee, had acquired much of the meadow for stock raising by 1859. He sold 480 acres to Andrew Miller in 1859, then sold the remainder, roughly 1000 acres, to Christian Lemm in 1867 and moved to Lassen County. Christian Lemm and his son Frank continued to graze cattle on their ranch in the meadow, but by 1908, Oro Light and Power had purchased most of the valley with plans for creating yet another water-storage reservoir. This plan was never realized, even after Great Western Power Company bought out Oro Light and Power. The last remnants of a town disappeared, and by the early 1920s, only the Millers, Lemms, and a few summer residents remained.

This may be Andrew Miller in his buggy. Andrew acquired land in Humbug in 1859 but had business ventures and held the position of federal land office agent in Susanville, making for a long commute. His family often stayed over in Humbug, with his sons running affairs there as they got old enough, while his daughter Mabel ran the Longville Post Office. This photograph has been identified by another source as Miller's brother-in-law.

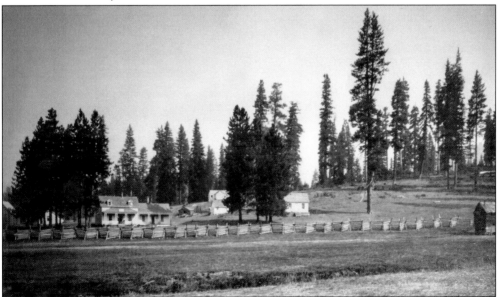

Here is the original Miller home and hotel in Longville, located in Humbug Valley. This house burned the year after Andrew's death in 1903. A new, larger Victorian-style house was built on the ridge to the right. That house remains a landmark in Humbug Valley to this day.

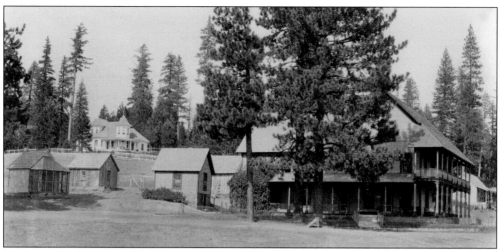

To the rear is the present-day Miller house as it appeared about 1910. Frank Miller built the house for his mother in 1909. Down in front of the house was the last Miller Hotel, built beside Humbug Road, which connected Oroville to Big Meadows and Susanville.

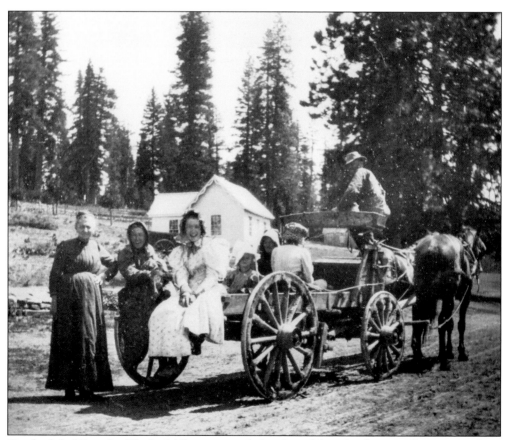

On the left, "Grandma" Lydia Miller visits with family and friends who are off on a picnicking expedition, perhaps to pick berries.

In a comedic moment, here is a summer kitchen detail at the Millers' house in 1909. The Durkees and Campers, close family friends from Chico, as well as Harry Wardlow from Greenville, give the ladies a break. Durkee and Camper family members still stay in Humbug every summer.

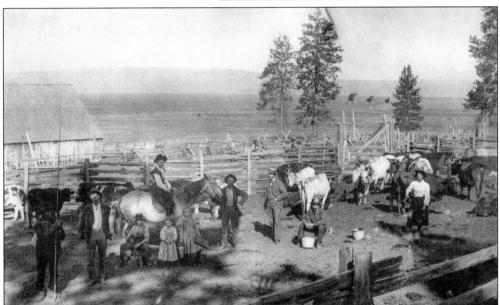

Here are members of the Lemm family in the corral during milking. The ranch was divided among family members and much of it was sold off, but great-grandson Paul Lemm still retains a piece of land and the last residence.

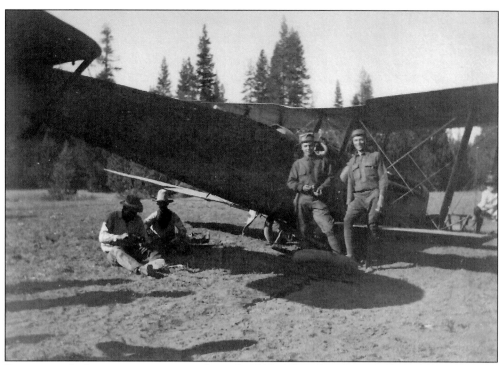

Progress reached even remote areas in the early 1900s. This plane has nosed into the meadow in Humbug. One might wonder what repairs were needed and how parts, not to mention fuel, were obtained. The pilot and copilot seem unconcerned.

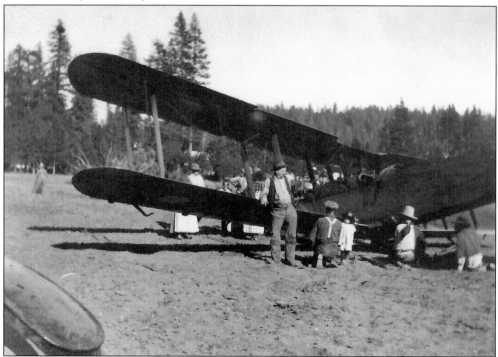

Of course, an event like the plane crash attracted a lot of interest from the local residents.

Andrew and Lydia Miller's son Frank became the head of the family after Andrew's death in 1903. He built the new home for his mother in 1909, which is now a Humbug landmark.

A summer camper samples the water of one of the soda springs in the valley. Frank Miller rocked the spring outlet in 1903. People still use its water for carbonated lemonade or lemon and vodka concoctions known as "muddlers."

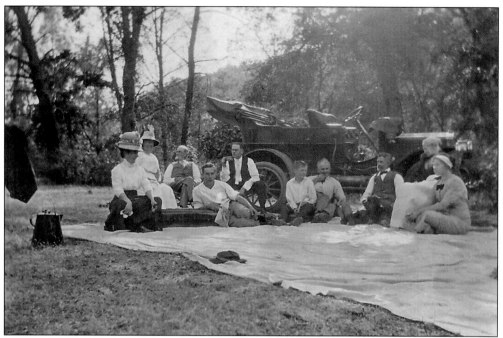

Here is a Durkee family and Camper family picnic on the road. The families visited every summer to hike, fish, and make treks to surrounding areas like Butt Valley, Seneca, Big Meadows, Chester, and the Feather River Canyon.

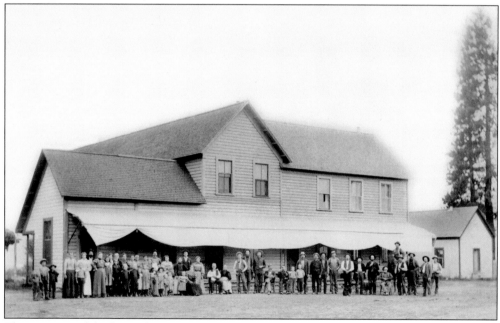

This image is of the large Plummer Welsh hotel in Longville with most of the valley's residents posed in front. A fire on July 18, 1904, destroyed a large part of the hotel, and two four-year-old children—Ester LaPerry, the daughter of a waitress, and Milton Miller, the grandson of Andrew and Lydia Miller—died in the fire. They were buried together in the Janesville Cemetery in Lassen County, with the year of death incorrectly recorded as 1905.

Five

BIDWELLS

Henry Bidwell, son of Daniel Bidwell, came to California in 1849 from Mexico, where he had served in the Mexican War. During his first few years, he worked on the boats for the Sacramento Steamboat Company, carrying freight and emigrants up the river as far as Red Bluff. He married Julia Poole on February 7, 1857, in Sacramento, and then invested money he had earned in mercantile businesses with his father, Daniel, in Butte County and explored opportunities in Plumas County. By 1860, California pioneer John Bidwell, his brother Daniel, and Daniel's son Henry were acquiring property in Big Meadows. Henry invested heavily in mining ventures in and around Indian Valley, becoming president of the Green Mountain Gold Mining, the Cherokee, and the Gold Stripe Companies. He was behind the creation of the Round Valley Lake; mining requiring large amounts of water to wash the ore. Round Valley Reservoir became the source for the Bidwell-founded Greenville Water Company, later owned and run by Henry's son Augustus (or "Gus") and grandson Bruce.

In 1862, Henry established the first mercantile store in Greenville. He and father Daniel, meanwhile, had built a small resort near the base of Big Meadows called Meadow View, and the Bidwells began collecting the tolls on the nearby bridge over the North Fork. Henry was running Meadow View in the summer, and by 1863, he was paying an annual license fee of $6.67 for operating an eating house (an annual retail liquor license was $13.33). Meadow View was also passed on to Gus after Henry's death in 1880. The family had a home in Oakland to winter in, but they spent a large part of the year running their business interests in Plumas County. Gus owned and operated an iron foundry in Greenville. His father, Henry, had been instrumental in getting Western Union telegraph service to Indian Valley and Big Meadows by 1874, with Gus learning to use the telegraph key, as did other young men in the area. By 1885, Gus bought wire from a failed effort to run a telephone line from Susanville to Greenville and used it to connect Greenville to Quincy, then to Big Meadows, and finally, to the outside world.

Mining and dairy ranching were still the primary industries in Big Meadows in the 1860s, but the building of the Humboldt Wagon Road by John Bidwell and partners, construction of the Red Bluff-Susanville Wagon Road, and continuing improvements on the Humbug Road and county roads from Greenville and Quincy made travel and freighting much easier. Not only local residents benefitted. The 1860s saw the birth of the tourism industry, as at first hundreds—and later, thousands—sought escape from the summer heat in the Sacramento Valley with its accompanying

illnesses, such as malaria. Many families came and camped every summer on the same ranches for a small fee. A tradition of large camping groups of families from towns like Gridley, Hamilton City, Oroville, or Live Oak was established.

Even John Bidwell and his wife, Annie, camped for a time most summers on their own acreage on the west side of Big Meadows, located below the Stover Ranch. They were fond of naming their favorite camping spots, and the Big Meadows site was called Robin's Nest, the name Annie later attached to the summer residence she built on the property after John's death in 1900. Like Annie, many visitors craved the comforts of four walls, a roof, and a floor. They stayed at the Bidwells' Meadow View, the very small Big Springs hotel run by Henry Landt, the small Butterfield Hotel, or the much larger Prattville Hotel, which had launched the growth of the small town of Prattville.

Daniel Bidwell (1807–1887) was John Bidwell's half-brother. A Vermont innkeeper, he followed John to California, taking up a ranch and building a home on the Esplanade in Chico a few miles north of brother John's estate. Daniel and John acquired land in Big Meadows in the late 1850s to the early 1860s.

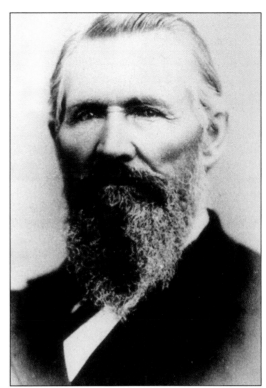

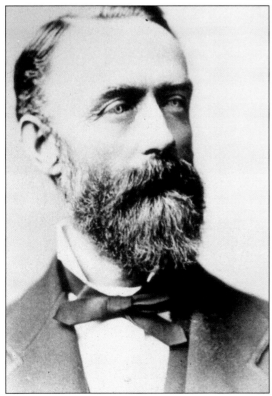

Henry Bidwell (1831–1880), Daniel's son, left his home in Vermont for Boston at age 13. He joined the Army during the Mexican-American War, coming into California from Mexico in July 1849. He first worked for the Sacramento Steamboat Company on the Sacramento River. By 1860, he was president of several Northern California mining companies. He built the first merchandise store in Greenville in 1862.

49

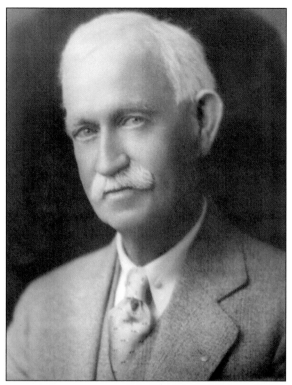

Augustus "Gus" Bidwell, Henry's son, was born in California in 1859 and succeeded his father in the family businesses at age 21, following his father's unexpected death. Gus founded the Greenville Water Company in 1886, using water from Round Valley Reservoir, which had been built to provide water for gold mining and milling. Gus's son Bruce sold the water company in 1976.

Here are Gus and his wife, Clara Bartling Bidwell, in front of their Main Street home in Greenville with son Bruce and daughter Elsie.

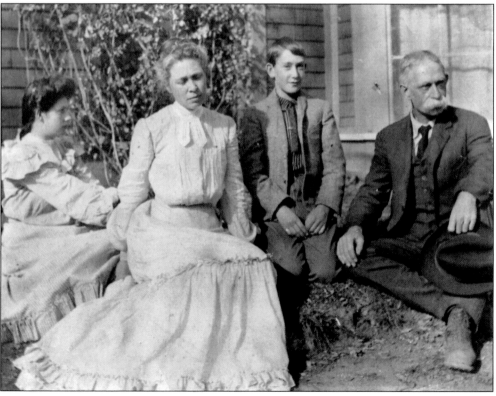

Bruce Bidwell is seen fishing in a Maidu-fashioned dugout canoe on Big Springs about 1904. The Maidu had always left the canoe at Big Springs for anyone who wished to use it. Bruce and his father, Gus, eventually hauled it down to Oroville and gifted it to a pioneer museum there; they did the same with the remains of Lassen's cabin.

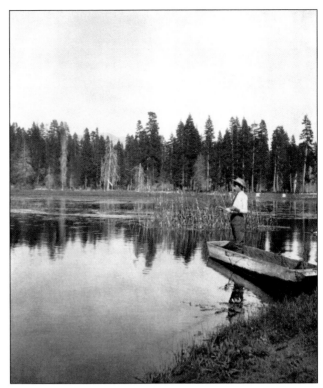

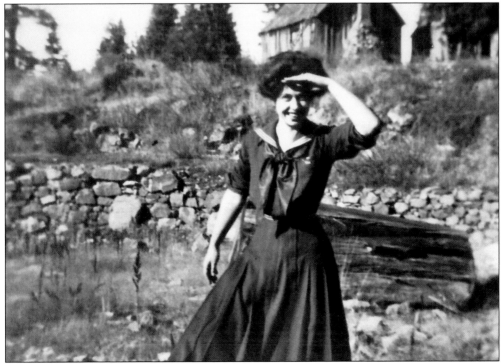

Bruce probably took this photograph of his sister Elsie in Gibson girl–type dress at the site of the original 1854 bridge over the Feather River, near the Bidwell resort of Meadowview.

Here, Elsie poses near the "modern" Bidwell bridge over the river near Meadow View. It was a toll bridge, and the Bidwells were licensed to collect the tolls.

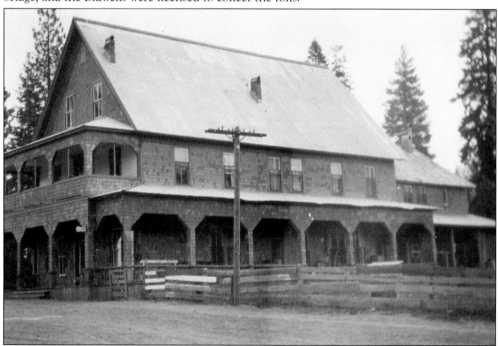

The Bidwell resort, Meadow View, was the first large hotel on the east side. This large hotel was constructed as a later edition of the smaller hotel built in the 1860s by Henry and Daniel Bidwell. It offered meals and rooms to summer visitors, traveling businessmen, and miners wishing for a few comforts by 1863. Henry was also licensed to collect tolls at the nearby bridge.

This winter scene at Meadow View, with Gus and Clara Bidwell, clearly demonstrates why most Big Meadows hotels, as well as other businesses, closed in winter.

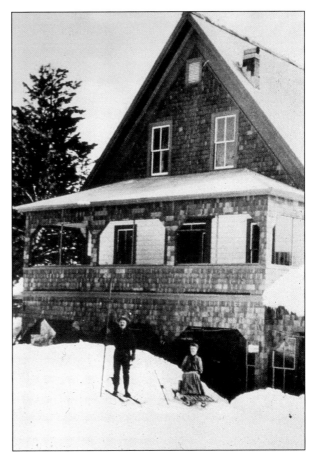

The view of Big Meadows from the aptly named Meadow View is one of the attractions that drew guests. The line of trees along the rise on the left is the point behind today's boat ramp, situated near the dam.

This painting done by a visiting artist, depicting the meadow in front of Meadow View, was given to Gus and Clara Bidwell and later handed down to their son Bruce. Bruce had it hanging in his living room in Greenville as a beautiful reminder of days gone by.

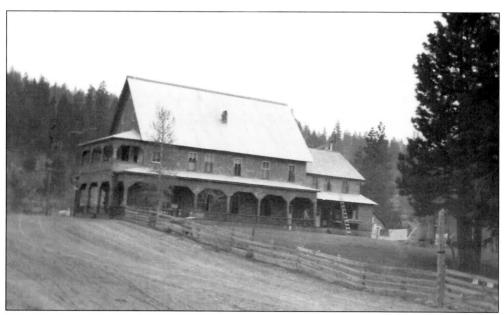

This side view of the Meadow View hotel shows its proximity to the ridge along which the current East Shore Highway 147 was built after the creation of the lake flooded the older, lower roads.

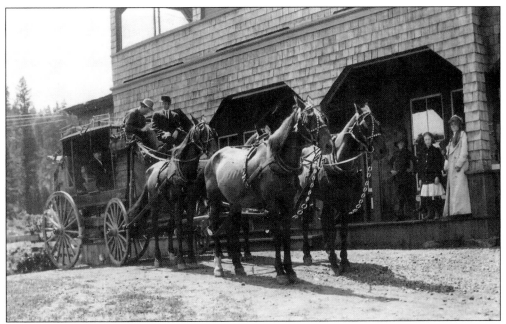

Elizabeth Taylor and her daughter Edith are seen on the porch at Meadow View, which was closed for guests but still operating as a stage stop and a telephone/telegraph office. Gus Bidwell was the first citizen of Big Meadows to sell to Great Western Power Company in 1901. He then worked hand in glove with the company's operatives to help them acquire options on his neighbors' properties, which was later seen by many as a betrayal of trust.

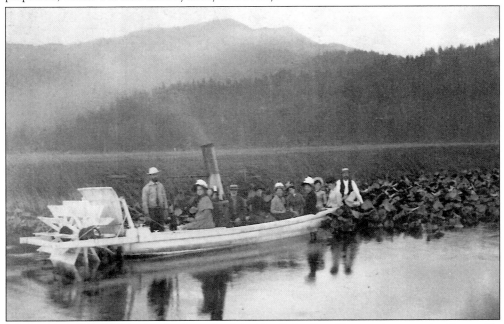

This tiny steamer, the *Meadow Lark*, was built by Gus Bidwell and his employees at the Greenville foundry Gus owned. Made of riveted metal plates stabilized by a sugar pine keel and trim, it steamed proudly on the river in Big Meadows, as seen here in 1889. It took a large team of at least 12 horses to haul it up from Greenville.

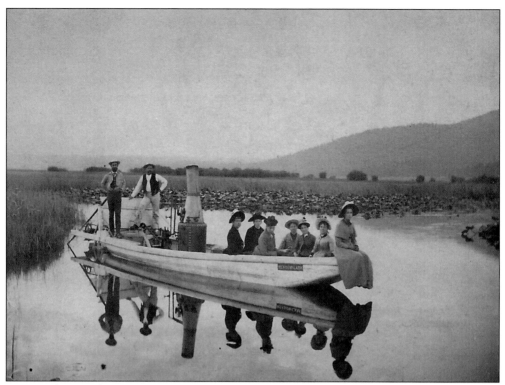

In 1889, the *Meadow Lark*, with Clara Bidwell on the bow, hosts a 10-year reunion of the first group of women allowed to graduate from the University of California, Berkeley in 1879. Gus is standing at left.

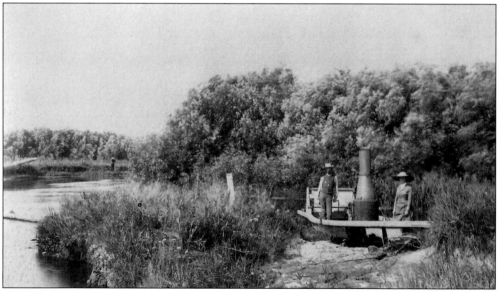

The *Meadow Lark* is pictured beached in Big Meadows with Gus and Clara Bidwell. Gus could only operate the steamer for a few years because local ranchers started irrigation projects that dropped the water level enough to make the river unnavigable for the paddleboat. It now resides at the Chester–Lake Almanor Museum.

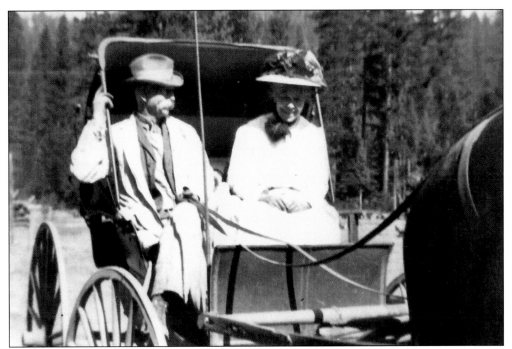

This is a delightful photograph of Gus and Clara Bidwell in their buggy in Big Meadows. Within a few years, this couple's marriage was strained, perhaps due to Clara's feelings about her husband's role in Great Western Power Company's activities.

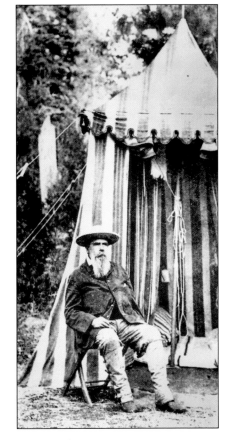

Here, John Bidwell is pictured on one of his camping adventures. He was a founding officer of the company that built the Humboldt Wagon Road, connecting Chico to Big Meadows, Susanville, and points in Nevada and Idaho. It was planned to make Chico a major supply depot for the settlements and mines to the east.

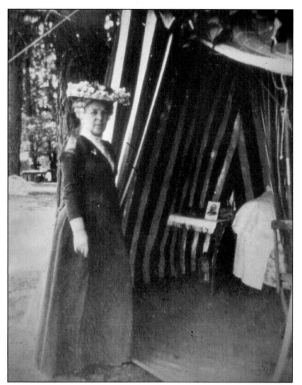

John Bidwell's wife, Annie, enjoyed camping out at various locales in the mountains with her husband, John. They first camped, then built a rustic cabin on John's property between Prattville and the Stover Ranch. Each of their favorite camping places received a title; their spot in Big Meadows was Robin's Nest.

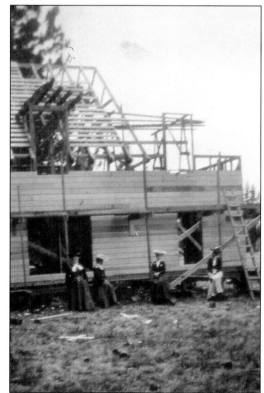

In 1904, Annie Bidwell began construction of a home meant to be a comfortable summer retreat at Robin's Nest. A master carpenter named Hamilton, unrelated to the resident ranching Hamilton family, was hired, and work commenced.

When the upper floor had been laid, Annie reported that she and the builder Hamilton chalked outlines on the floor for the layout of the rooms.

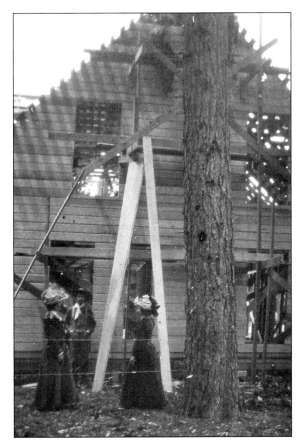

Annie (third from left) and her guests, including friend Augusta Gibbs (sitting in joist), kept an eye on the progress of the cabin's construction. Visible in this image are the joists for the wraparound porches that would be screened to keep out flies and mosquitoes, while offering cool sleeping accommodations.

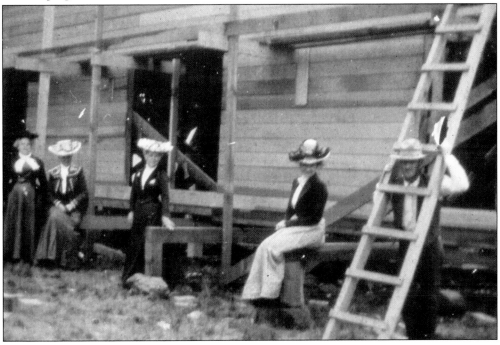

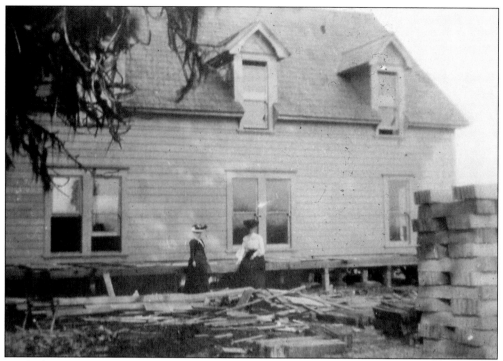

As the house nears completion, one can see the gables with their distinctive trim. These gables are still visible on the house today. Annie and Augusta continue to supervise the progress.

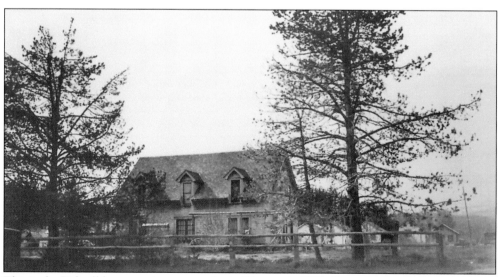

This is the Bidwell house on its current site in Chester in 1935. Originally painted a "robin's egg blue," it was later painted white by cattleman Earl McKenzie, who acquired the house in the mid-1920s. He had it skidded into Chester using Caterpillar tractors borrowed from the Red River Lumber Company in Westwood.

Annie Bidwell and her friend Augusta Gibbs visited Drakesbad in 1904, escorted by Bidwell coachman and ranch foreman Reuben Messinger. Reuben always accompanied Annie on her trips, often bringing his family. Annie had a cabin built for Reuben at Robin's Nest.

In spite of heavy layers of clothing, Annie and Augusta hiked to Boiling Springs Lake and Devils Kitchen while at Drakesbad.

MRS. BIDWELL SELLS BIG MEADOWS LANDS

GREAT WESTERN POWER COMPANY PAYS $30,000 FOR 800 ACRES FOR RESERVOIR PROJECT

CHICO, June 27.—The Great Western Power Company has purchased from Mrs. Annie K. Bidwell the 800 acres owned by her at Big Meadows, where the power company expects to develop a huge reservoir by the erection of a mammoth dam, which is to be the largest power generating project in the world. The sale was made June 21st, but was not made public until yesterday. The price paid is said to have been $30,000.

Included with the sale is "Robin's Nest," Mrs. Bidwell's seventeen-room summer cottage.

This article from the *Plumas National Bulletin* on June 29, 1911, details Annie's sale of the Big Meadows property and Robin's Nest to Great Western Power Company. She possibly needed the money from the sale, but evidently her conscience pricked her. Her first act upon her return to Chico was to consult with her minister.

This small cabin, built by the Bidwells in 1898, may have used as a Presbyterian chapel. It was skidded into Chester and used as a church by visiting ministers before eventually becoming the property of the Wesleyan Methodist Church. It exists to this day, enclosed within the walls of the current church.

Church at Chester, Cal.

Six

PRATTVILLE

Dr. Willard Pratt was a native of Canton, Pennsylvania, who followed his father into the medical field, studying medicine at the University of Pennsylvania in Philadelphia. Following his graduation in 1847, he moved west and opened his medical practice in Fennimore, Wisconsin, near Madison. There, he met a pretty lass from England: Sarah Hart. They married on June 14, 1848, and started a family, having two little girls: Emily in 1849 and Annie in 1851. Being the only physician in the area, Pratt made a living, but the stories coming east of the riches found in California lured him west. He signed on with a wagon train in 1852 as the company's doctor, but a delayed start resulted in his leaving Sarah, who had become pregnant again. Pratt thought the trip too hazardous for her in that state and made her promise to name a boy baby for him. In the spring of 1853, a third baby girl arrived, and Sarah tried to stay true to her word, naming the baby Wilhelmina. The lively youngster was always called "Willie."

Pratt arrived in Placerville, California, without incident and made very good money, investing in real estate there and, later, Colusa. Fires wiped out his investments, but he soldiered on. Meanwhile, Sarah was both homesick for England and for her husband. In 1859, she packed up the girls and left by ship for California. The reunited family settled a short distance north of Chico, buying a ranch from John Bidwell at Four Corners, where three more children were born: Thomas in 1860, Martha Jane ("Mattie") in 1863, and son Marion in 1866.

While on business in Oroville, Pratt happened to meet a former patient and friend of his father's from the east, Jacob Benner. The Benner family had a ranch in Coal Canyon at the foot of Table Mountain but summered with their cattle in Big Meadows. After hearing of the Pratts' suffering through the heat of summer in Butte County, Benner heartily encouraged him to visit Big Meadows, offering to let the family stay on the Benner ranch. The family visited in the summers of 1865 and 1866 and found the place very beautiful. Emily Pratt and John Benner fell in love and were married in 1866.

That summer, Dr. Pratt was asked to call upon Thomas Bidwell, half-brother to John Bidwell and Chico's postmaster. Thomas was staying at Landt's place on Big Springs, suffering from tuberculosis, so there was little Pratt could do for him. During that visit, Pratt saw a large log cabin on a big spring about a mile west of the North Fork. Finding that there was land also available, Pratt purchased 550 acres along with the cabin, which belonged to a man named Houck, who had moved on to Quincy.

Settling his family in their new home in 1867, they soon found the new house very crowded. Their home was on the Humboldt Wagon Road, which was by now well traveled, as gold and silver had been discovered in Nevada and Idaho. A stage line had been established from Chico to Ruby City, Idaho, with few stage stops. Dr. Pratt was known as a very hospitable man, and daughter Willie's spirited greetings made "Willie's Hotel" a popular stopover. Shortly, however, Sarah ran out of patience, and told him if they "were going to run a hotel he'd better build one." Chico's *Northern Enterprise* reported, "The big 4th of July [1873] party on the opening of the new hotel at Prattville was a grand success . . . with over 100 ladies present." Undoubtedly, the Benner Brothers' Band played, as they did for many local dances and celebrations. The joyful spirit was short-lived, however. The Pratts leased the running of the hotel in 1875, in order to attend the nation's big Centennial Exposition in Philadelphia. The hotel burned to the ground while they were gone.

Not to be undone, once again, by fire, Willard Pratt set to work building a new, bigger hotel between 1876 and 1877. The new hotel, built at a cost of $10,000, featured 26 sleeping rooms (though no. 13 was used for storage), parlors for both ladies and gentlemen, family rooms, and dining rooms. It opened on July 4, 1877, with a patriotic celebration and music, this time provided by the Greenville Brass Band. It was filled every summer, operated by Willard and Sarah until Dr. Pratt's death in 1888, and then by son Thomas and his wife, Julia, until its sale in 1892. Thereafter, it was leased to other operators until its sale to Great Western Power Company.

In the meantime, Willard Pratt served as unofficial mayor of the new village that grew up around his hotel and the official postmaster of the Prattville Post Office. Pratt had requested the name *Big Meadows* for the new post office, but that had already been used for the previous location, so the local residents then requested Prattville, which was how Plumas residents knew the place. Prattville became the government's official name for the location. Willard Pratt subdivided his property close to the hotel, and the small town grew up rapidly.

Next to the hotel was a large freight barn and blacksmith shop. The main street was purposely wide; the space was intended to make it easier to turn large freight and stagecoach teams. In the center of the street was a public well with a cement curb and watering trough. Directly across from the hotel were two mercantile establishments: the Abbott Store, run by New England native Hiram B. Abbott, and the Benner Brothers' Store. About 1900, the Benner Brothers' Store became the Costar-Stover store, operated by Rob Costar and his wife, Josephine Stover Costar. Rob had previously operated a smaller store in the old store building up the street, owned by the Dotta family. Just past the Abbott and Benner stores was the hop-covered saloon, operated by the Sorsoli brothers, Frank, James, and Stephen. Frank Sorsoli would build a new hotel next door to the saloon in 1909. Several other families built their homes in the village, and a school was added at the end of the street.

During the last two decades of the 19th century and the first decade of the 20th century, Prattville reigned as the social and business center of the township. Its numbers would dwindle in the cold months, as many residents left for the Central Valley or the Bay Area to escape the rigorous, isolating winters. Some, like former schoolteacher Nettie Abbott, lived in second homes in Chico or Red Bluff in winter so their children could attend school, especially high school, and receive a better education. Others, like the Bidwells, Deans, and Cadles, with perhaps more assets, had homes in Oakland or San Francisco for the winter. The students in Big Meadows attended school from April to October, due to the difficulty of winter travel, and education ceased at eighth grade. Many local families wanted their daughters in particular to finish high school, and many young ladies went on to study at Chico Normal in order to teach school until they married. A small number of Big Meadows youths attended the University of California, Berkeley.

Those hardy ranching families who wintered in had to lay in enough food, kerosene, and supplies for months of winter, never being sure just how long each winter would last and when the roads might open. They purchased flour by the ton, sugar by the barrel, kerosene by the gallons, and raised much of their own fruits and vegetables, which they canned or pickled. It must have been exciting each spring when the first freight teams made their way over the summits and into the meadows.

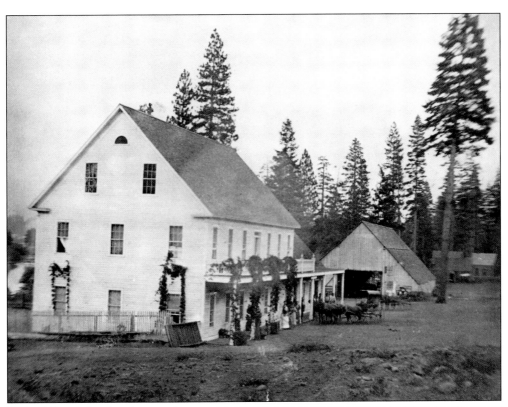

Willard Pratt's first hotel opened with much hoopla in July 1873. Behind the hotel is the big spring branch that fed the Feather River. Down the road are the hotel's barn and livery stable, followed by a blacksmith's shop.

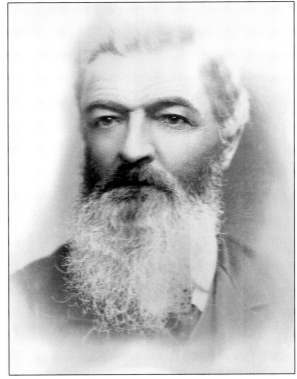

Pennsylvania native Dr. Willard Pratt set out for California in 1852. He moved his family to Big Meadows in 1867, seeking respite from the heat and disease of summers in the Central Valley. He died in 1888 and is interred the Prattville cemetery. (Courtesy of Plumas County Museum.)

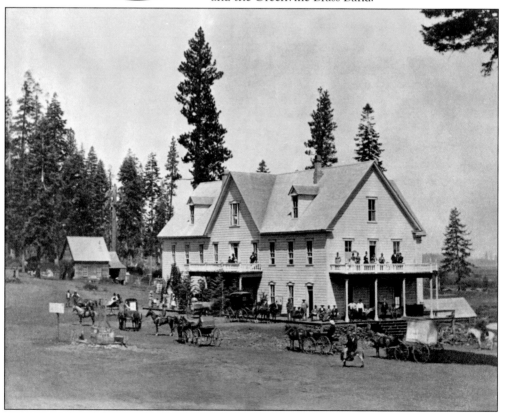

Sarah Hart Pratt emigrated from England to Wisconsin in the 1840s to join her brothers and keep house for them. Marrying the town's doctor was not as settled as she might have expected, as it led her to California on her own in 1859 with three small daughters. (Courtesy of Plumas County Museum.)

Pratt's second hotel was constructed in 1877 following the fire that destroyed the first hotel during a family visit to Philadelphia for the national centennial in 1875–1876. The centerpiece for the town of Prattville opened with much ceremony and the Greenville Brass Band.

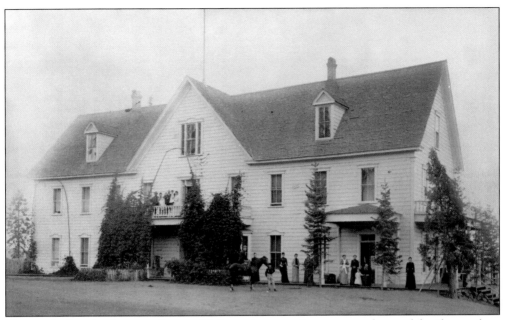

Here is the hotel a few years later, with hop vines growing over porches and family members and guests posing. The hotel offered 26 "sleeping rooms," a ladies' parlor, a gentlemen's parlor and smoking room, a dining room, and Pratt family quarters but no saloon, as befitted a high-class establishment.

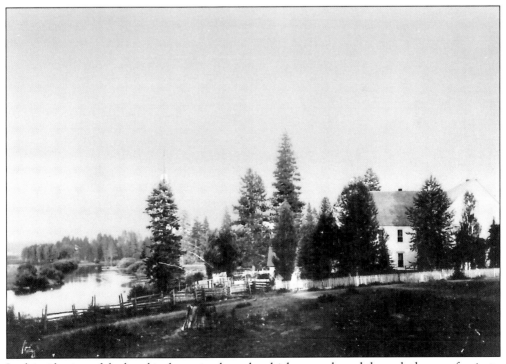

In this side view of the hotel is the spring branch, which was enlarged through the use of weirs to allow boating. There was a small dock at the back of the hotel with rowboats for guests to use.

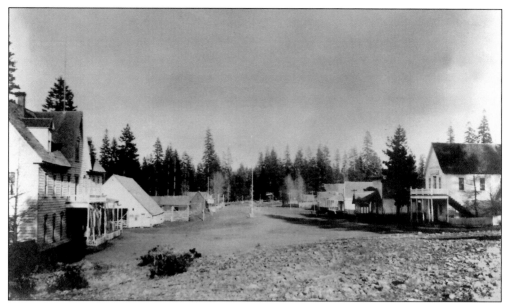

Here is a classic main street view, with the hotel, barn, and livery on the left and three stores and a saloon across the way. The street is deliberately wide to allow for the turning radius of large freight teams. In the center of the street off in the distance is the community well, with its cement curb, small watering trough, and flagpole.

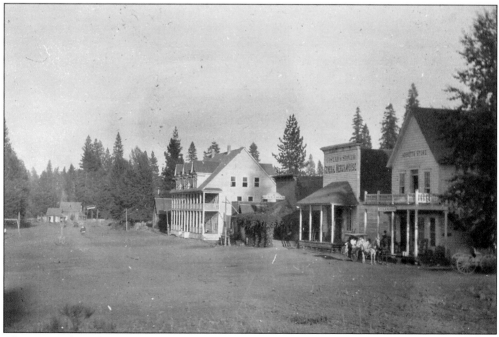

This image shows how Main Street looked in 1909. Abbotts' Store featured a community hall upstairs used for public assemblies and dances. Next door was the Costar-Stover store, followed by the hop vine–covered Sorsoli Saloon. Behind the saloon a new hotel was being built by Frank Sorsoli to accommodate the ever-increasing numbers of summer visitors.

Hiram Abbott came to California during the Gold Rush but quickly switched to the mercantile business, settling in Big Meadows by 1860. He served several terms as the local justice of the peace, performing weddings as well as meting out justice. (Courtesy of Plumas County Museum.)

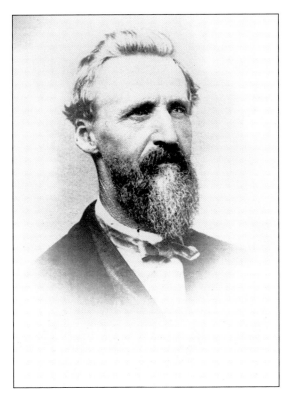

Nettie Stubbs Abbott had sought adventure and opportunity in California, coming from Maine as a schoolteacher. Her career was short lived; she met and married Hiram in June 1872. After losing their first son in 1873, they had daughters Julia in 1874 and Annette in 1877 and son Edward in 1879. After Hiram's death in 1889, Nettie ran the store with the help of her children. (Courtesy of Plumas County Museum.)

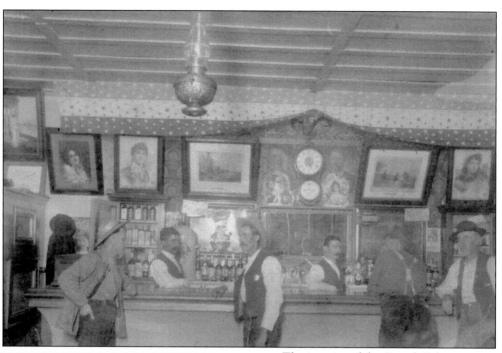

The interior of the Sorsoli Saloon features the usual saloon decor of the day. Bartender brothers Frank and Stephen Sorsoli attend to customers, including the area's constable, possibly Milton Copple.

THE SORSOLI SALOON

PRATTVILLE, CALIFORNIA.

An up-to-date saloon, furnished with high-grade liquors of all kinds, and cigars.

Good billiard tables and neat club rooms.

Celebrated J. H. Cutter Whisky

The patronage of the public is solicited.

Frank Sorsoli, - Prop'r.

Here is an advertisement for the Sorsoli Saloon from the *Plumas National Bulletin*, promoting its amenities.

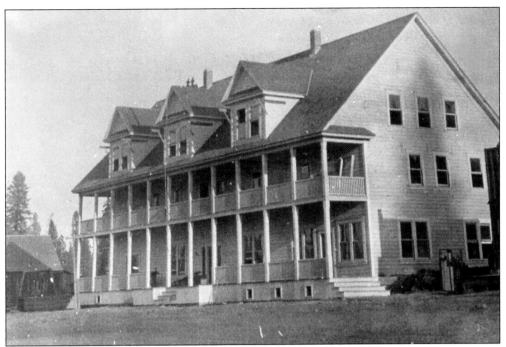

It is June 1909, and the Sorsoli Hotel nears completion. Prattville was expecting a large crowd for the Fourth of July festivities they were hosting that year. Willie Pratt Sommers and her daughter Helen would be the first guests to stay, before the hotel was officially opened.

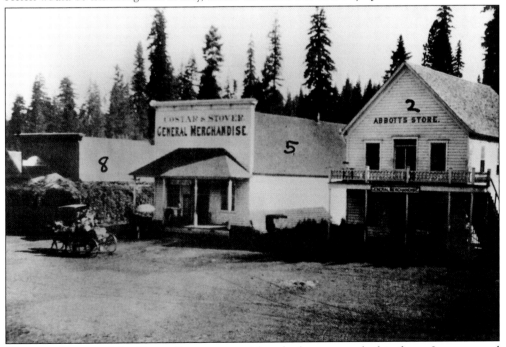

This is a close-up of the Costar-Stover store with a donkey cart parked in front. It was owned and operated by Rob Costar and his wife, Josephine Stover Costar, perhaps with assistance from Josephine's brother Harry "Jake" Stover.

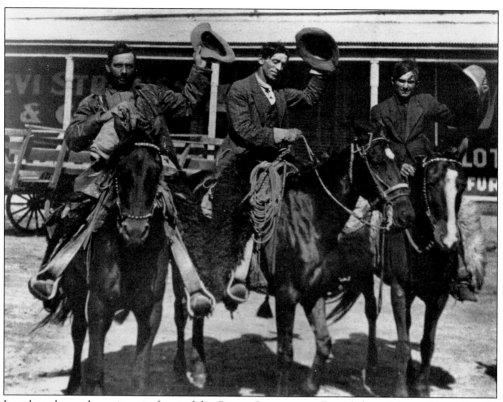

Local cowboys whoop it up in front of the Costar-Stover store. From left to right are Harry Smith, Bert or Earl McKenzie, and a young unidentified cowboy. Woolly chaps, sometimes dyed bright colors, were the cowboy fashion statement of the time.

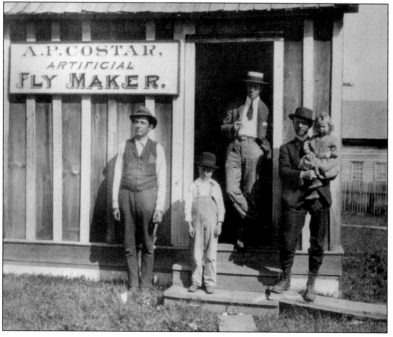

Rob Costar's younger brother Alburn "Ab" Costar operated this fly shop to supply fishermen needing flies mimicking the insects the fish were biting at the time. Big Meadows hosted avid fishermen from as far away as Europe.

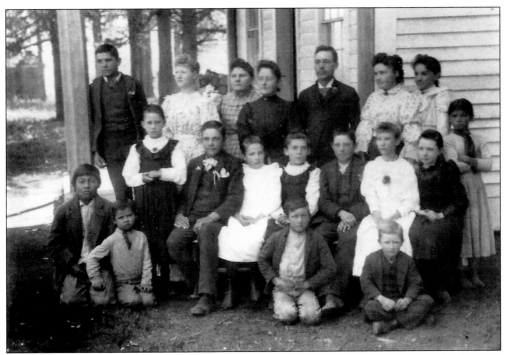

This is an image of the Prattville School from around 1885. There were at least three schools in Big Meadows: one on the east side, one at Prattville, and one in the northwest in what would become Chester. Winter made travel so difficult, school was in session from April through October.

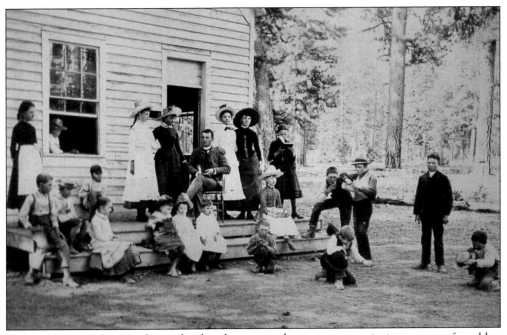

Pictured here is a Big Meadows school with some students at recess enjoying a game of marbles. This is probably on the east side, as several of the older girls look like Hamilton daughters. Formal schooling ended for these students at grade eight.

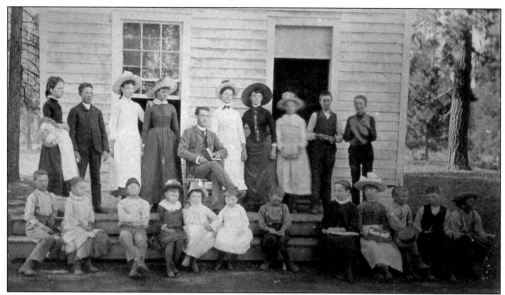

Here is a different view of the schoolchildren posing, with a reluctant scholar (first row, third from left) impatient for the photography process to be over. This was probably the last day of school for the term. Students wishing to proceed to high school usually boarded in Chico or Red Bluff. Many local girls continued their studies at Chico Normal in hopes of becoming teachers themselves.

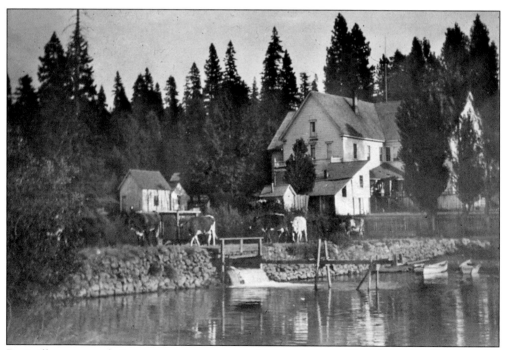

Prattville cows on their way to pasture are crossing a weir controlling the spring flow into the meadows. Divers thinking they have found the hotel's foundation are more likely to have found one of these dikes. Some of the hotel's rowboats can be seen beached at right.

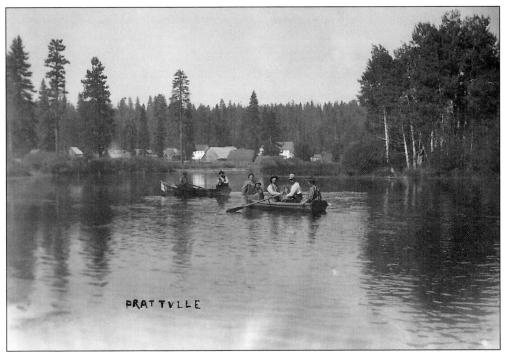

Boaters enjoy a row about the Pratt Spring branch behind Prattville. Nearby Lover's Island, at right, was a popular picnic and courting destination.

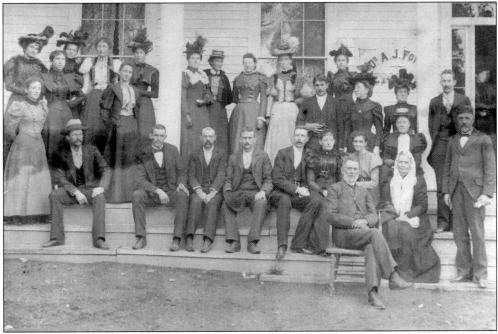

Many citizens of Big Meadows and Prattville gather in the late 1890s or early 1900s for a social occasion, possibly a dinner and dance. Included in this image are members from the Abbott, Stover, Benner, Cadle, Gleason, and Olsen families. In front are Thomas Pratt (seated in the chair) and his wife, Julia, next to him.

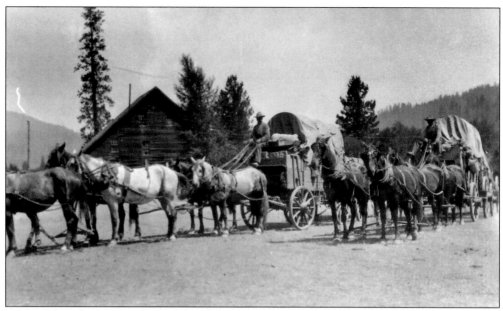

Life could not have existed as it did without frequent visits from freight teams like these, shown in Taylorsville. Freighters made up the majority of the traffic on the stage roads from Quincy, Chico, Oroville, and Red Bluff.

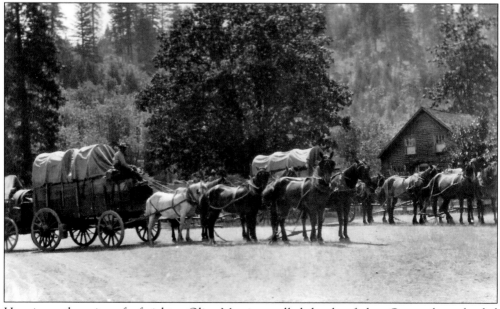

Here is another view of a freighter. Olive Martin recalled that her father, Oscar, always loaded his front wagon with the cans of coal oil or kerosene, probably for safety's sake. Families would have needed these fuels by the gallon for lighting.

This classic photograph of a stage on the narrow Humboldt Road demonstrates the dust and dangers of stage travel through the mountains. Female passengers, and some males, commonly wore dusters and hats with veils for dust protection. This method of dress was necessary, along with goggles, for early automobile passengers.

This Bidwell family photograph, probably staged by Bruce, shows the peril of early automobile travel. The Bidwells were among the first families in Big Meadows to have an automobile. Though autos became more common during the dam construction. Drivers had to defer to horse-drawn vehicles, since many horses panicked at these strange beasts.

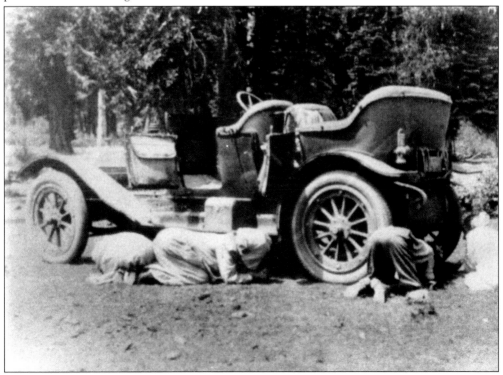

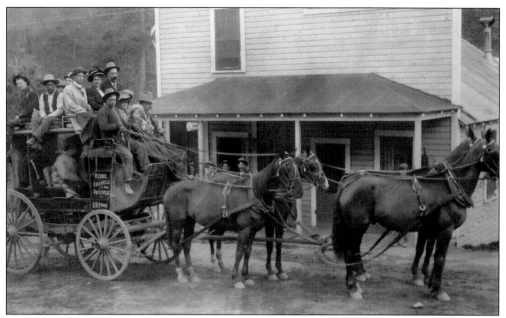

The local stage from the Keddie train station to Prattville shows the increase in passengers due to the beginning of dam construction in 1910. Great Western Power Company shipped their construction supplies by rail as well, creating heavy traffic on the new Wolf Creek Road from Greenville to Big Meadows.

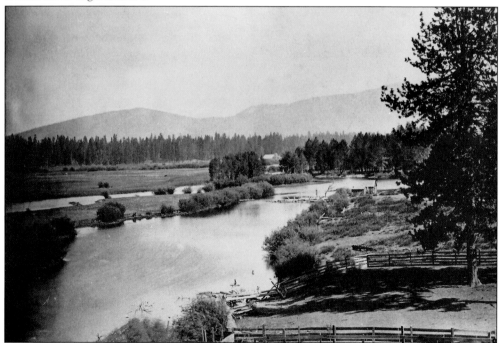

This is a view of the meadows behind Prattville toward Bunnells. The 1909 Fourth of July celebration started with a picnic and baseball game in the meadows about a mile from the town. Some people became aware of smoke rising from town, and the crowd ran back to find nearly the whole town ablaze.

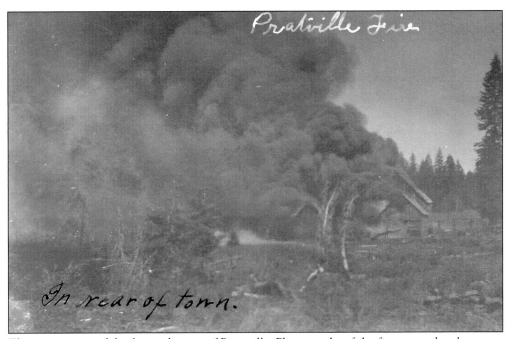

This is an image of the fire at the rear of Prattville. Photographs of the fire were taken by young Bruce Bidwell, who galloped in on his horse, Kodak Brownie in hand.

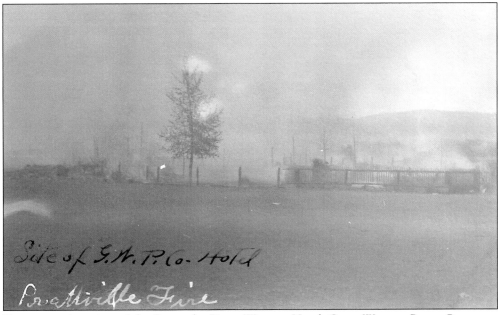

Here is another view of the fire at the Great Western Hotel. Great Western Power Company, builders of the Almanor Dam (also known as the Canyon Dam), had purchased the Prattville Hotel in 1908 to house engineers, supervisors, and guests.

Site of G.W.P. Co. Barn

Prattville Fire

The hotel barn was also ablaze; it is unknown if horses were housed there at the time or if any animals were rescued.

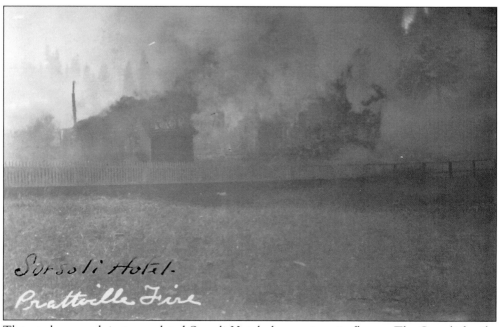

Sorsoli Hotel.

Prattville Fire

The newly opened, just completed Sorsoli Hotel also went up in flames. The Sorsoli family, however, was one of a very few business owners who rebuilt.

An article in the *Lassen Weekly Mail* on July 7, 1909, pretty much summed up the consequences of the fire. From that day forward, there was public suspicion about the origins of the fire, with most residents convinced it was the work of Great Western Power Company. Many were equally sure that Gus Bidwell, or men he hired, started the fire.

The town of Prattville was consumed by fire on Saturday last The fire is supposed to have originated in the rear of either the Costar or Abbott store. At the time the blaze was discovered there was a game of base ball being played and nearly everyone was attending that. Fourteen buildings were destroyed; which nearly wiped the village out of existence. Every business house was consumed by the flames and the loss is estimated to be about $75,000. Frank Sorsili had just completed a fine hotel and this was also destroyed. Under the existing conditions it may be some time before Prattville will be rebuilt, that is, as it formerly was.

Rob Costar restarted his mercantile business in one of the few structures left. The old original store building where he had first opened his business is seen at left. His freight team is visible in the background, as is the second Sorsoli Hotel (far right), with a well and tank house nearby. Citizens of Big Meadows still needed store goods.

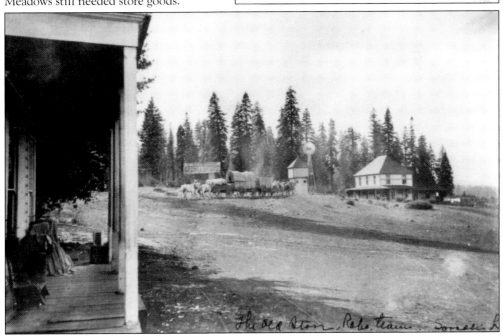

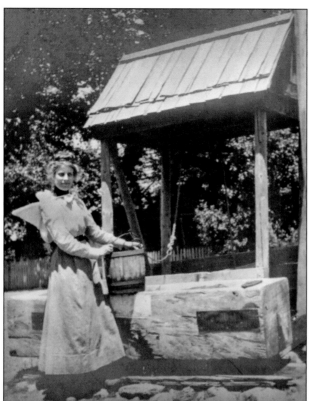

This recently discovered photograph offers a close-up view of the public well in the center of Prattville. One of the Costar daughters, bonnet on her back, is filling the bucket while standing in front of the watering trough for animals. Most residents of Big Meadows relied on natural springs on their property or nearby streams for their household water.

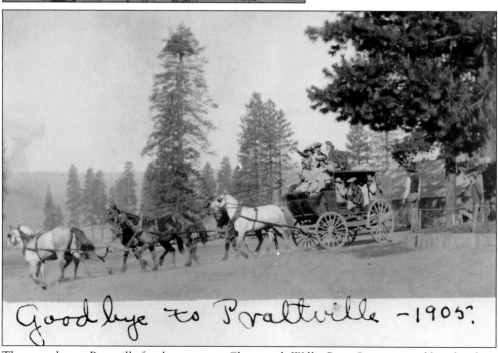

Goodbye to Prattville – 1905.

The stage leaves Prattville for the return to Chico with Willie Pratt Sommers and her daughter Helen on board. Little did they realize how prophetic this caption would become.

Seven

BUTTERFIELDS, BUNNELLS, AND LEES

The 1880s saw the real flowering of tourism in Big Meadows, with thousands of visitors each summer. Many were still escaping the heat of the great Central Valley, but more were coming to sample the scenic wonders of the area, venturing out on pack trips to Lassen Peak, various hot springs, and fishing streams. Three intermarried families—the Butterfield/Costars, the Lees, and the Bunnells—became adept at meeting the needs and wishes of the tourists.

When Julia Lee married her late husband's partner, Luther Wellington Bunnell, in 1869, they ranched nearly 940 acres of land and, in 1886, built a hotel on a parcel near the river, situated about a mile from Prattville. That first hotel, with its flat, mansard-style roof, burned on July 10, 1899. Julia and Lute rebuilt almost immediately; the second hotel was larger and more attractive and became the premier destination for visitors from as far away as Europe. It was three stories and in the shape of a T. The leg of the T housed the dining room, kitchen, pantries, and storerooms, with the servants' room upstairs. The kitchen was the domain of the Chinese cook, his helpers, and three waitresses. Nothing but the freshest dairy, meat, and vegetables were served, with nearly all sourced right on the ranch.

The first floor of the Bunnell Hotel featured a central hall with an elegant staircase. The office and men's lounge were to the right. The lounge was furnished with desks, card tables, and spittoons, but no liquor was served. Sporting prints of fish and game were on the walls.

On the opposite side was the ladies' parlor with starched white curtains, relaxing chairs and rockers, and a piano. This room, along with all the bedrooms, had an aroma from the fresh cut hay that was spread under the carpets. The deluxe second-floor bedrooms were reserved from year to year by important Bay Area families. In addition, small cottages across the road were available for families or larger parties. Behind the hotel were the laundry, two bathhouses, and the necessary privies.

Guests could relax on the two long porches, explore the area on trail rides, or fish the river and adjoining Bunnell Spring branch. The hotel had its own boathouse, with boats made by local Maine native George Butterfield, who also supplied the Prattville Hotel with boats for rowing on the large spring-fed pond behind it.

By 1910, when Great Western Power Company began dam construction, both hotels, along with most other lands in Big Meadows, were in the possession of the power company. Great Western Power Company had banned fishing in the meadows' streams and the North Fork,

to deliberately invoke the company's water rights and ownership. The Bunnells, like many longtime residents, had retired to a new home, located on the corner of Roop and North Streets in uptown Susanville.

Jim Lee and his wife, Julia, had moved to a ranch in Big Meadows, near Prattville, in 1861. He died there in 1864 at age 38, leaving a young wife with two young children. He was buried on the ranch but reinterred in the Prattville cemetery with other pioneers when the dam was being enlarged in 1926.

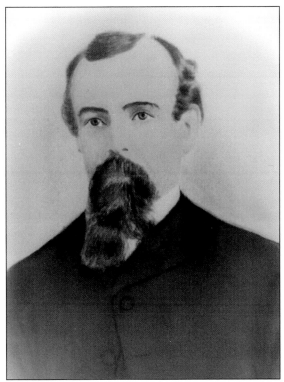

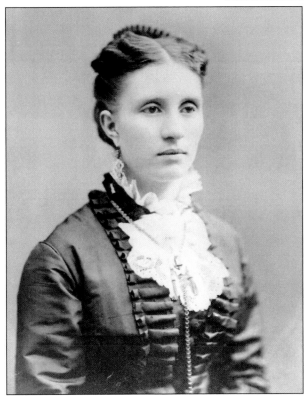

This is Julia Lee Bunnell as a young woman. In 1869, Julia married her late husband's former partner, Luther Wellington "Lute" Bunnell, and together they operated a large ranch, raised her children, and ran a hotel that was the crown jewel of Big Meadows.

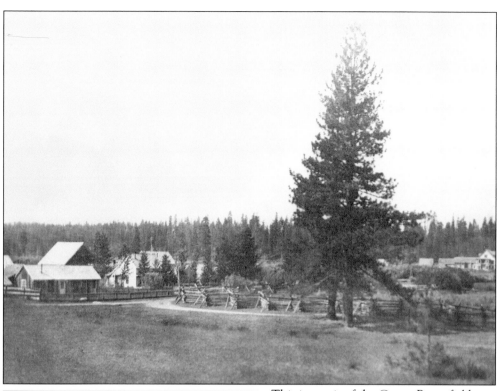

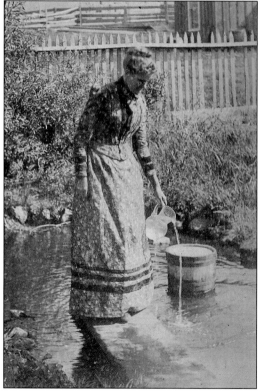

This image is of the Costar-Butterfield place, with the Bunnell Hotel to the right. The Butterfields were about halfway between Prattville and Bunnells and operated a small hotel for summer guests. Ab Costar, Elizabeth Costar Butterfield's youngest son, managed the property sometime after 1900.

Here, in a photograph labeled "Maiden at the Well," Eva Costar Lee dips water from their spring

Pictured here are Eva Costar Lee and her older sons: three-year-old Winfred (center) and six-year-old Charles "Charlie" Lee Jr. The Lees were prosperous, especially after selling their Butt Valley property, and the boys had toys and, of course, ponies.

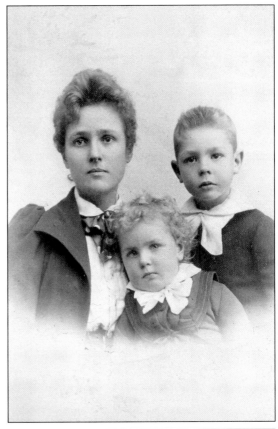

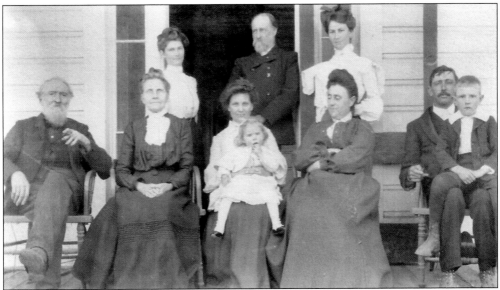

The Butterfields and Lees entertain Capt. Samuel Day, standing at center between Costar daughters Jennie and Matilda. Sitting from left to right are George Butterfield, wife Elizabeth Costar Butterfield, Eva Costar Lee (holding son Winfred), sister-in-law Martha "Mattie" Lee, and Charles Lee Sr. (holding Charlie Jr.).

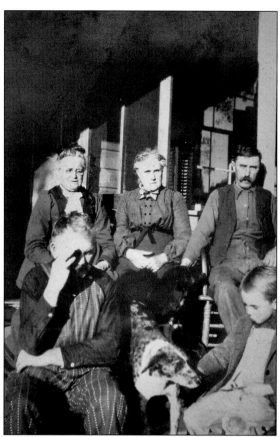

Pictured here are, from left to right, (first row) Lute Bunnell (shading his eyes) and Charlie Lee Jr. with his dog; (second row) aunt Lena Miller, Julia Lee Bunnell, and Charles Lee Sr.

George Butterfield is pictured working on a boat. A Maine native, George must have learned this craft in his youth. He kept local resorts supplied with boats used by fishermen who would hire local youths to row them on the large spring branches.

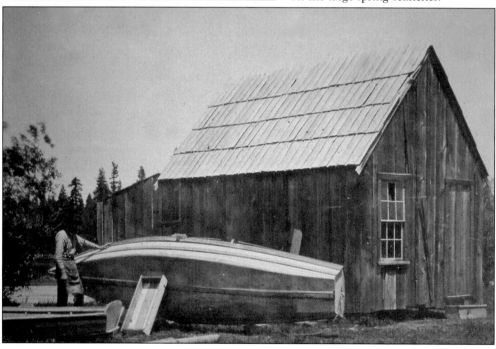

George Butterfield works inside his shop. This small shop might have originally belonged to Elizabeth's first husband, Thomas Costar, who was a house painter by trade.

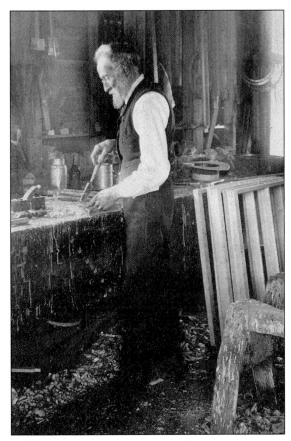

Shown is Charles Lee Sr. flanked by sons Winfred (left) and Charlie Jr. (right) and their ponies. On the porch are Elizabeth Costar Butterfield and Eva Costar Lee.

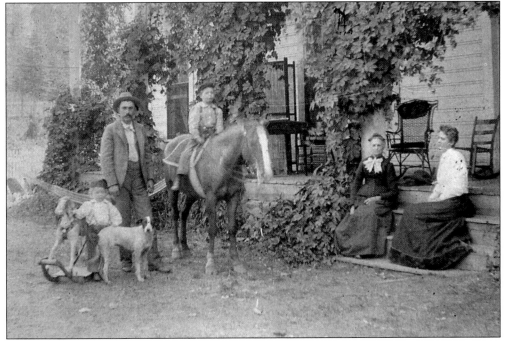

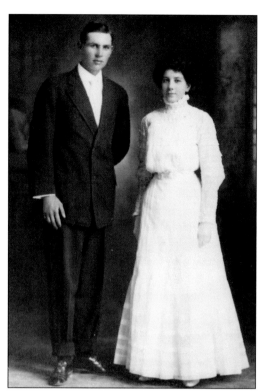

This is an image of young Charlie Lee Jr. and his bride, Minnie Kueny, in 1910. Charlie became the manager of the Red River Lumber Company dairy, which was situated in Mountain Meadows across the Red Bluff-Susanville Wagon Road from the Tunison chimney that still stands near Highway 36. Charles died in the Westwood Hospital in 1917, just after his 30th birthday, due to a septic infection of the gall bladder.

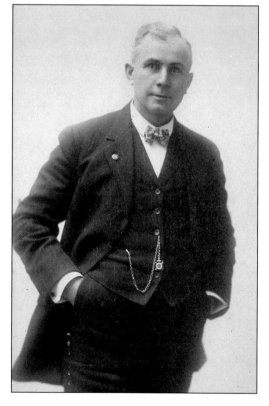

Charles Lee Sr. used the funds from the sale of Lee ranches to Great Western Power Company to buy a large part of Warner Valley above Chester. He and Eva continued to raise cattle there but also built a popular resort, Lee's Camp, and sold small parcels to people wanting a vacation cabin in the cool mountain air.

Swiss-Italian dairyman Peter Guscetti, seen in this 1904 photograph, sold his holdings in Warner Valley to Charles Sr. and Eva Lee.

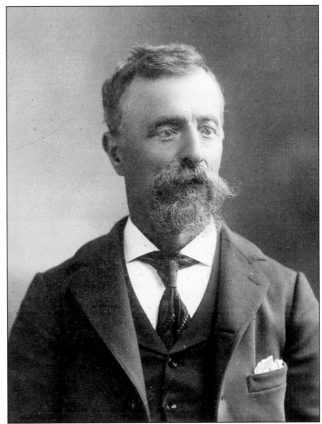

Lassen View Lodge was part of the Lee resort in Warner Valley. It offered a breathtaking view of Lassen Peak, including a front-porch view of the peak's eruptions between 1914 and 1917. Charles Lee Sr. is on the right, beside the steps.

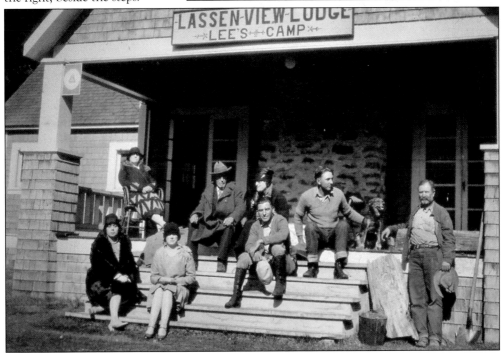

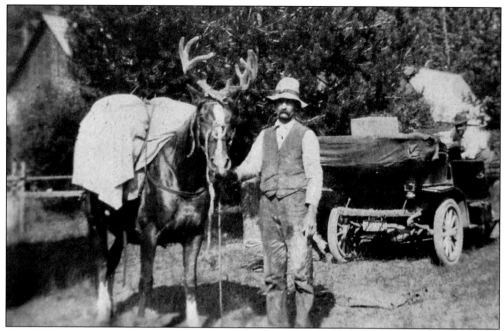

This very patient horse has just returned to Lee's Camp after packing hunters' gear on a hunting trip. Horses also packed parties on trips to the scenic volcanic wonders of the Lassen region. The Lees' resort was successful from the start, getting a big boost in business from the interest in Lassen Peak's eruptions after May 1914, being situated as it was on the road to the peak through Drakesbad.

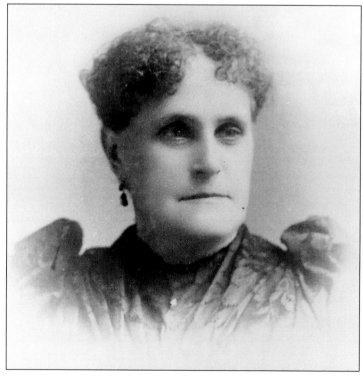

This is a portrait of Julia Lee Bunnell in her later years, when she was renowned for the hospitality and meals she provided at the Bunnell Hotel. (Courtesy of Plumas County Museum.)

Luther Wellington "Lute" Bunnell, known for his genial disposition, savored his role as host. His knowledge of the area was unsurpassed, having arrived during the high tide of the Gold Rush and living in the area for over half a century. (Courtesy of Plumas County Museum.)

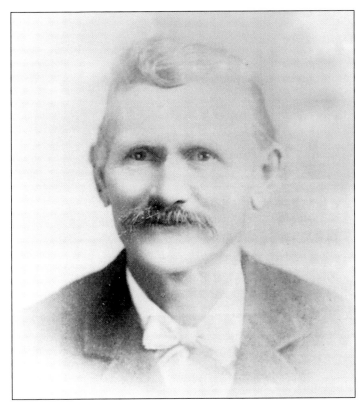

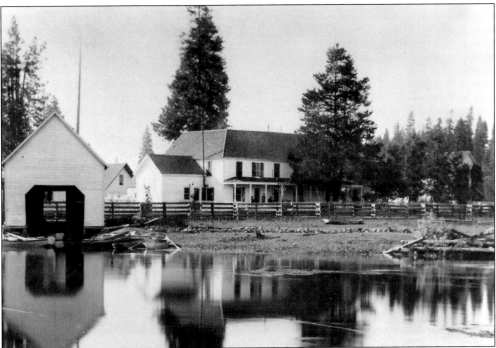

This is an image of the first Bunnell Hotel when it was initially built in 1886, showing the boathouse on the Bunnell Spring branch of the Feather River.

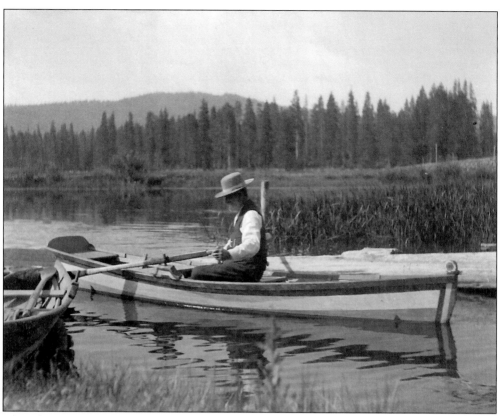

This photograph of George Butterfield during a boat trial of one of his well-crafted rowboats provides a stunning picture of the beauty of the springs and river at the Bunnell Hotel.

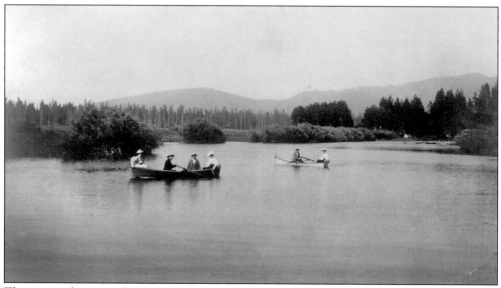

This image shows two boating parties rowing near the Bunnell Hotel. Fishermen hired young men to row them about, but many people went rowing to savor the simple joys of cool water and beautiful scenery.

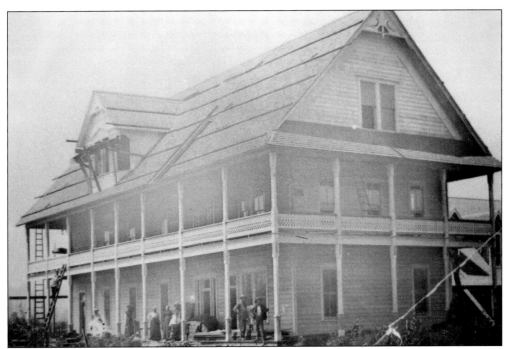

Here is the second, larger Bunnell Hotel under construction in 1899, giving clues about the construction techniques of the time. It offered unparalleled views of the river and Lassen Peak. (Courtesy of Plumas County Museum.)

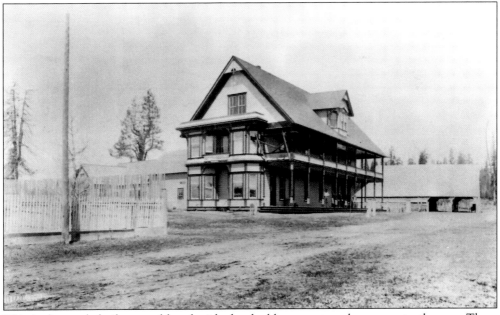

This is the newly built second hotel with the double-entry stage barn seen to the rear. These allowed stagecoaches or buggies to pull under shelter before unloading passengers. The fenced area to the left is part of the hotel garden.

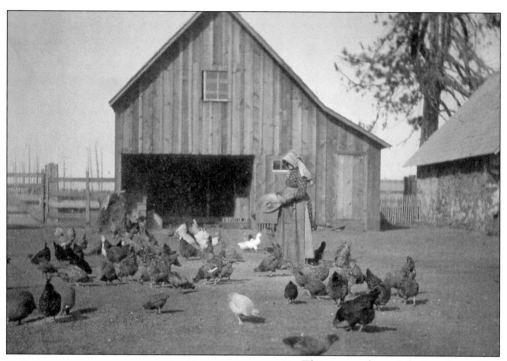

This image shows Julia Lee Bunnell feeding part of her flock. She proudly served the freshest meat and vegetables; most of the food her cook prepared came straight from the ranch. Only fruit unable to grow at this altitude was freighted in from the orchards in the Sacramento Valley.

Julia also raised ducks and geese, having a fenced area along a ditch to the side of the hotel for the waterfowl. Guests could order three different kinds of eggs for breakfast: chicken, duck, or goose.

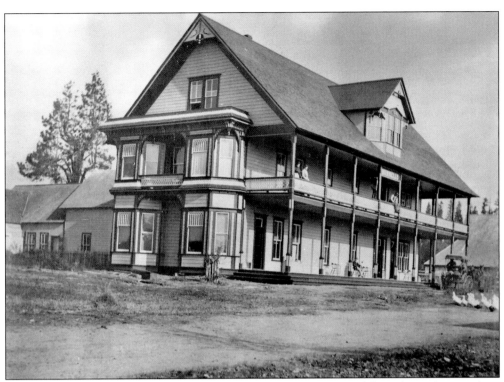

Geese parading past the hotel on their way for a swim was just one of the sights to be seen from the hotel verandas. Bruce Bidwell loved to sleep on the second-floor porch and awake to the early sun lighting Lassen Peak.

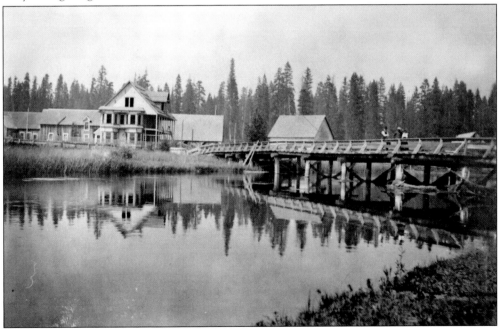

This is the second Bunnell Hotel during construction in 1899. The long bridge in front of the boathouse is seen at right. (Courtesy of Plumas County Museum.)

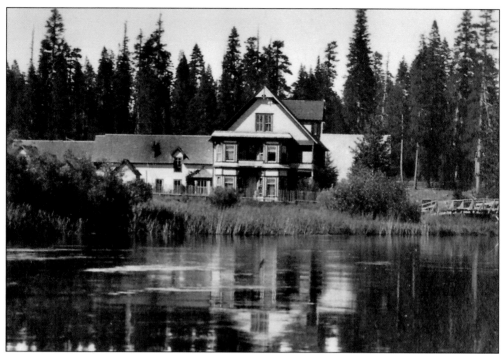

This side view of the Bunnell Hotel shows the kitchen wing and servants' quarters. Though three stories, the third floor of the hotel was never really used. It was a large open space, perhaps intended to be used as a ballroom. The floor was littered with pots and cans placed there to catch leaks from the roof when it rained.

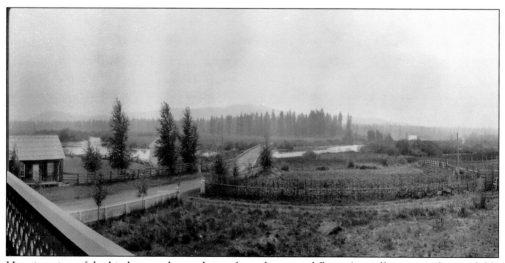

Here is a view of the kitchen garden and river from the second floor. A small cottage, also available for rent, sits across the road. The white building behind the two trees is the boathouse.

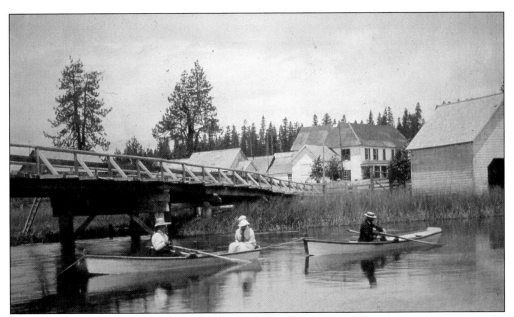

In this image of the first Bunnell Hotel, boaters enjoy a paddle near the bridge. This area was the lair of a legendary huge trout named Mike. On the rare occasions he was caught, he was weighed and measured and then thrown back in, regarded as too big for good eating. To local outrage, he was caught by a lady from the Sacramento Valley who refused to release her prize catch, taking him home on ice!

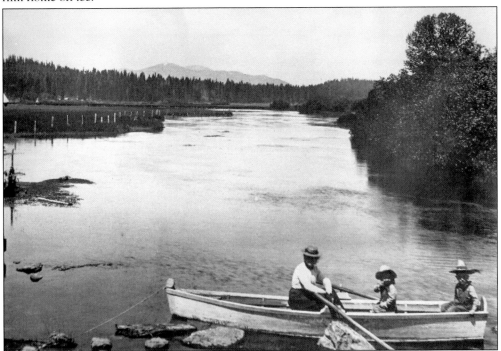

Maud Costar, wife of Ab, prepares for a row with her children Mary Alice and George about 1904. She and her husband managed the Bunnell Hotel for a few years before Great Western Power Company burned it down.

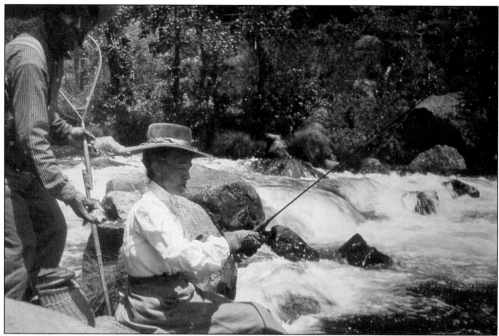

Mattie Lee, Julia Lee Bunnell's daughter, was an avid fisherwoman. Here, she hones her skills on the river rushing down the canyon from Big Meadows, accompanied by Piute Charley, her net man.

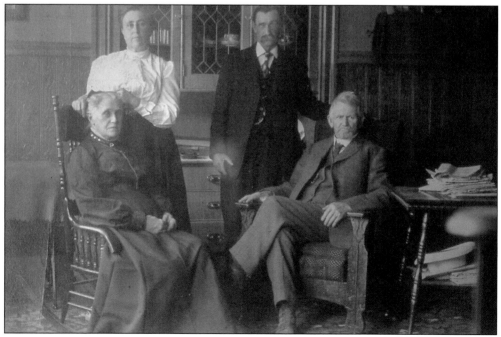

Julia and Lute Bunnell, who retired in Susanville, are pictured seated. Behind Julia stands daughter Mattie. The gentleman behind Lute is the nephew he raised, Lucius Bunnell, later known as "Lute" himself when he ran the store in Seneca.

Eight

WESTSIDE RANCHERS AND EARLY CHESTER

Scattered along the North Fork, upstream from Bunnell's resort, were several more ranches. Some like the Dottas, Peter Guisetti, and the Baccalas were sturdy dairy ranchers from the same Italian-Swiss canton in Switzerland. They mined for a while and then reverted to their old country profession. Others, like Norwegian Peter Olsen, the Benners, Reuban and Thaddeus Stover, Burwell Johnson, William Clark, and the Martins, had originally come to California seeking riches in the Gold Rush but, like Bunnell and the Lees, turned to agriculture or commerce.

The Stover brothers, Reuben and Thaddeus, and Peter Olsen were among the earliest settlers of the larger west side of the meadows. The Stover boys had come west to California with their father, Jacob Stover. Jacob returned east to his family after a bout of ill health, leaving his teenage sons on their own. Losing nearly all their possessions in the struggle to survive, the boys, like many older, wiser men, decided to become cattlemen, supplying beef to miners from a ranch out of Marysville. Seeking summer pastures for their stock, they teamed up with Peter Olsen, driving their herds up the Humbug trail from Oroville to the northwest end of Big Meadows in the late 1850s.

The Benners and William Clark held the far end, along Benner and Johnson Creeks, so Olsen and the Stover brothers settled permanently on opposite sides of the North Fork in 1859 and began dairying like their neighbors, Jeremiah and Melissa Bailey, who had just arrived in Big Meadows from the Midwest. The Benners and Clark were primarily beef cattlemen, who simply summered their herds here, and they later sold out to the dairy-operating Jonathan Martin family. Sons Oscar and Arthur Martin eventually held most of the land across the Red Bluff-Susanville Wagon Road from the Olsens' ranch, indeed, most of the land that later became the town of Chester.

East across the meadow was Burwell Johnson, whose property, like that of the Olsens, adjoined the new Red Bluff-Susanville Wagon Road, near today's North Shore Campground. Burt Johnson opened a freight and stage stop, providing teamsters a place to rest their teams before the long haul up Johnson's Grade en route to Susanville. In the early 1890s, the residents of the upper meadows were clamoring for a post office to alleviate the tedious journey to Prattville to retrieve their mail. Burt Johnson and Oscar Martin petitioned and received a contract in early 1894 for a new post office at Johnson's store, to be named Chester. Oscar Martin had been born in Chester, Vermont, while Missouri native Burwell Johnson had grown up across the Mississippi River from Chester, Illinois. Burt Johnson was appointed the first postmaster, a position he held until his death in December 1907.

After his death, the post office was moved 1.5 miles west to the front parlor of the Olsen ranch, and in 1908, the Olsens' widowed cousin Maude Gay was appointed as postmaster, a position she held until her retirement in 1940. About 1909 or 1910, the Olsens built a small one-room cabin in front of their home to house a tiny post office and store.

Melissa Bailey was widowed in 1867 when husband Jeremiah took ill and died in Chico while making butter deliveries to the valley. Running a dairy ranch as a mother of three small children—two sons and a daughter—must have become overwhelming, even with hired help. Concerned about her children's education and unwilling to make that buggy drive to Prattville twice a day, she petitioned the county for a school for all the children of the upper west side. In 1868, the Melissa School District was chartered, and the first classes were held in a one-room log cabin on Peter Olsen's ranch.

In 1870, Melissa married neighbor Peter Olsen and proceeded to have three more sons. With all the families in the northern end expanding, it soon became apparent that a larger school space was needed. Jonathan Martin sold 42.5 acres of land on the river, adjoining the Olsens' ranch, to Peter Olsen. The deed reserved a small central space for the district schoolhouse and lot. A one-room schoolhouse was built in the early 1870s for what would become Lassen Butte School District. That school lot is the current site of Chester Memorial Hall. The schoolhouse built on that lot is now sitting in the county road department yard, next to the airport.

Missouri native Burwell Johnson first came to Big Meadows as a partner of John T. Hamilton. He moved over to the northwestern section, building a ranch and a freight stop. In the early 1890s, he and Oscar Martin made an application to the US Postal Service for a post office at Johnson's store to be named Chester. Burt Johnson became Chester's first postmaster in 1894. (Courtesy of Plumas County Museum.)

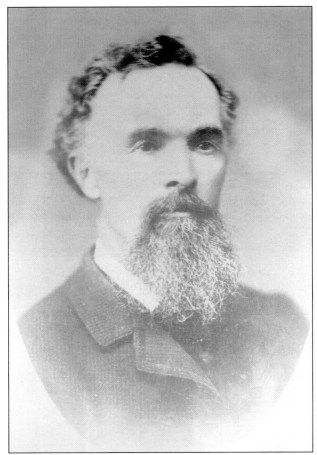

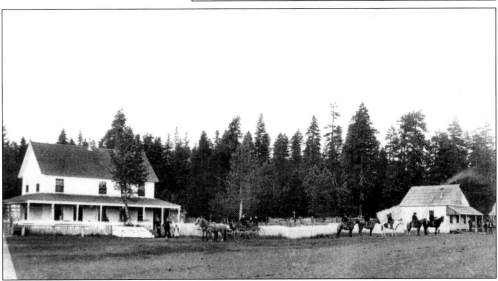

The Johnson home, store, and freight stop were situated quite close to the present-day North Shore Campground. Freighters often overnighted here so their teams would be fresh for the long haul up the steep Johnson's Grade.

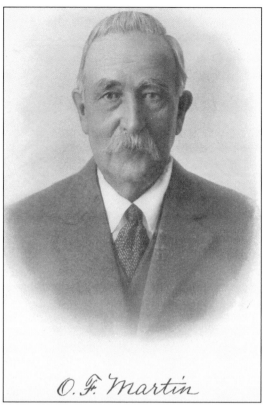

O. F. Martin

Oscar Martin was a native of Chester, Vermont. His father was superintendent of the Banner Mine in Butte County but settled his family in the northwestern end of Big Meadows in 1870. Brother Arthur ran the family dairy, while Oscar farmed in Butte County and ran a three-team freight line supplying his neighbors in Big Meadows. Oscar's big freight barn used to sit at the site occupied by the old Chester Fire Department. He was the first landowner to subdivide some of his land, leading to the founding of Chester in 1909.

This widely reproduced photograph of the road between Chester and Prattville was taken by Maud Butterfield Champion.

This is an early portrait of Reuben Hess Stover, who accompanied his father and brother Thaddeus to California at the beginning of the Gold Rush. Their father, Jacob Stover, returned home, leaving two teenage boys to support themselves. They soon took up cattle raising near Marysville and found their way to Big Meadows in the late 1850s looking for good summer pastures. They settled here on the river in 1860, building a ranch house in 1862.

Reuben Stover's wife, Mary Ann, in widow's black, sits with daughters Clara, Anna, Laura, and son Charley, who ran the ranch for his mother after his father's death in 1897. Standing are, from left to right, sons Merton and George with a friend. Charley eventually bought out other family members, becoming sole owner of the Stover Ranch.

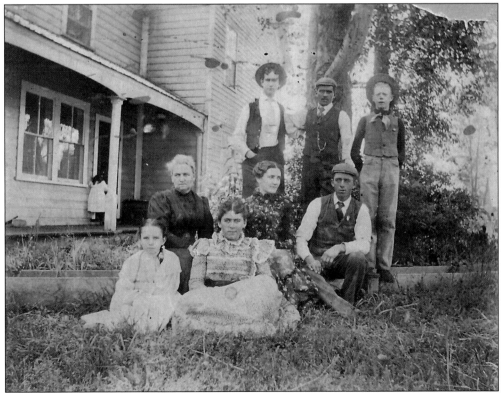

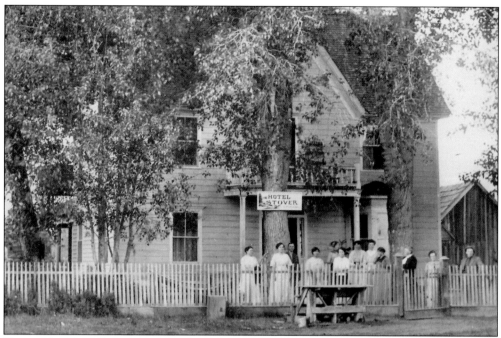

Here is the Stover home after 1910. Like other west-side ranchers, the Stovers started offering rooms and camping spots to guests, as hotels and camping areas disappeared in the rest of Big Meadows. This house was taken down in 1976 after a rising water table caused uneven settling that created instability.

This rare interior photograph of the Stover parlor demonstrates the amazing variety of goods available by freight, including a number of musical instruments. People back then had to provide their own forms of entertainment, and musical evenings were popular diversions.

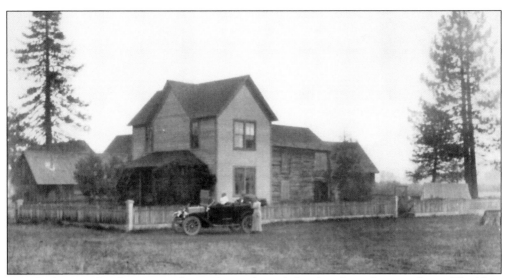

After both Stover brothers married, a need arose for each family to have their own home. Thaddeus built his bride, Ada Milroy Cooper, a home across the meadow on the other side of the ranch, which the brothers divided. Pictured is Ada in her Overland automobile, with Thaddeus in the backseat. Unlike Reuben's family, she and Thaddeus usually wintered in Chico, retiring there for good in the 1920s.

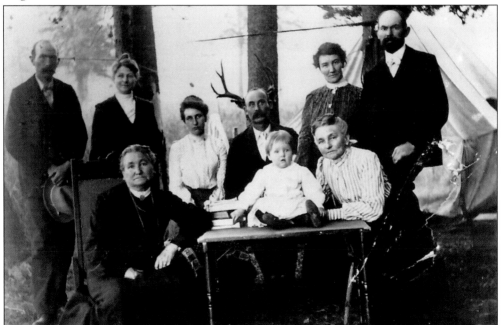

Norwegian Peter Olsen settled across the Feather River from his friends the Stovers. Olsen was a well-known barn builder, and his big dairy barn is now the only one still standing. When he died on Christmas 1892, he left three strong sons to care for the ranch and their mother, Melissa Bailey Olsen, wearing black and seated to the left. Her grandnephew Randall Gay and sister Lizzie Stuckey are beside her. Behind them are son George Olsen, niece Blanche Stuckey, granddaughter Olive Martin, son Frank Bailey, niece Maude Gay, and son Edgar Olsen. Peter and Melissa's son Nels Olsen was probably the photographer.

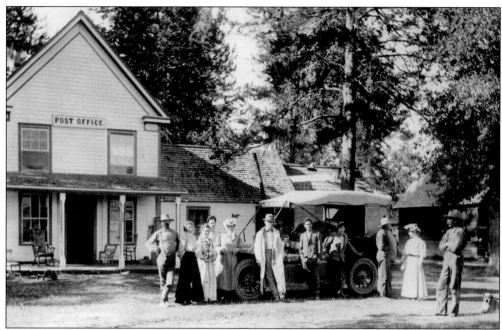

By 1908, the Olsen ranch house housed the Chester Post Office. Burwell Johnson had died, and widowed Olsen niece Maude Gay had become the Chester postmaster, holding that position for over 30 years. An auto has just arrived, delivering good friends and summer guests, the Morehouse family. They are met by Ed Olsen (far left) and George Olsen (far right). The bell on the beam above the auto was rung each day after milking to announce that fresh milk was available. It also served to call for help in an emergency.

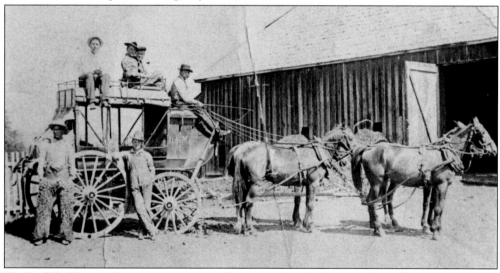

The Red Bluff-Susanville stage arrives at the Olsens' ranch with the mail. This well-worn photograph shows the second of three Olsen barns; this one is on the site of the Chester Catholic Church now used by St. Andrews Episcopal Church. Not as finely finished as the Butterfield and other passenger stages, this model was inelegantly referred to as a "mud wagon" for its ability to travel the muddy roads of the mountains. Today, the mail arrives on the Red Bluff stage in the form of a large, white, double-cab truck.

Printed from a broken glass plate negative by the author's brother, this photograph shows the interior of the Olsen dairy. In the rear left are racks built to hold the shallow milk pans while the cream rises. Ed Olsen is working salt into the fresh butter, while his brother George packs butter into a firkin. A tall mountain of fluffy butter on the scale awaits packing.

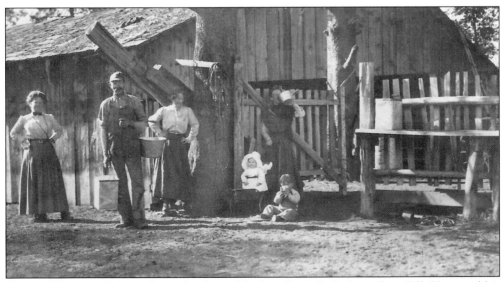

George Olsen stands by with two buckets of fresh milk while little nephew Bill Olsen and his mother, Carrie, sample the wares. Baby Freda Olsen seems content to wait her turn.

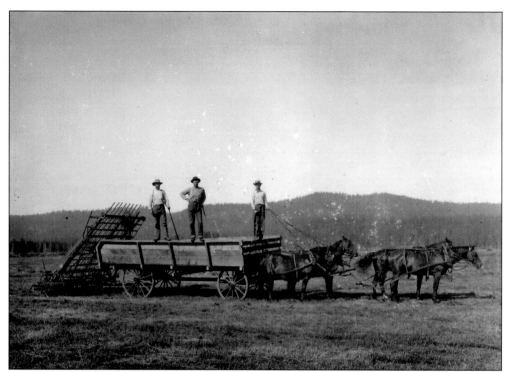

Pictured is a summer haying crew at work. Ranchers that wintered over, like the Olsens and Stovers, worked hard to ensure their herds would have enough feed for winter. The big barns had to be full by fall. During the winter, the families often had to shovel a path through snow higher than the cows' backs to get them to water.

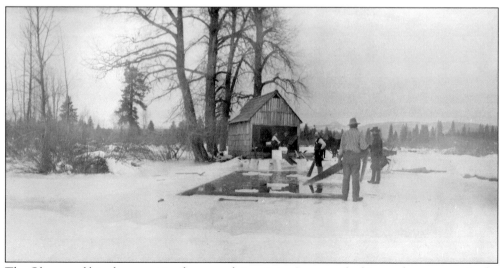

The Olsens and hired men cut ice from ponds in winter. It was packed in sawdust or straw in the icehouse at rear, to supply cool storage in the dairy, with some saved for the summer's homemade ice cream. (Courtesy of George Olsen Album and David Nopel.)

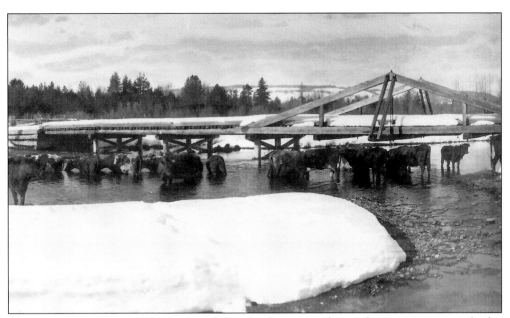

This is an Olsen photograph of some of their herd watering during the winter next to a bridge over Johnson Creek. Now this creek runs into Lake Almanor and through huge culverts under the east end of the Highway 36 causeway.

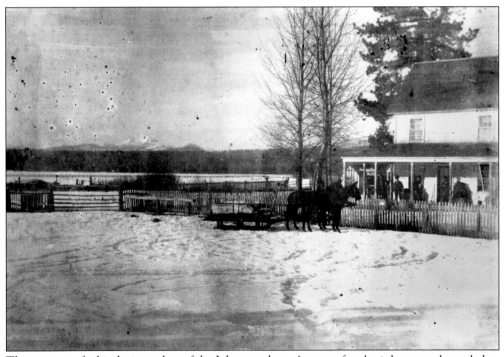

This is a one-of-a-kind winter shot of the Johnson place. A team of mules is harnessed to a sledge, used to pull heavy loads like hay or firewood across the snow. In the background appears a familiar sight: Lassen Peak. (Courtesy of Plumas County Museum.)

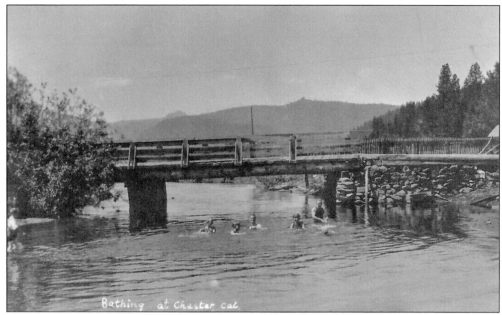

In the summer, Johnson Creek was a popular swimming hole. These bridges required frequent repairs, as woodpiles would rot. Replacement stone foundations would last much longer.

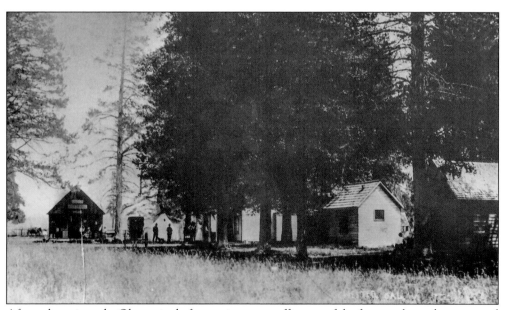

After a short time, the Olsens tired of operating a post office out of the front parlor and constructed a small post office and store building for Maude Gay in the front yard. To the right of the store is one of the tents for summer campers. The ranch house is hidden by trees.

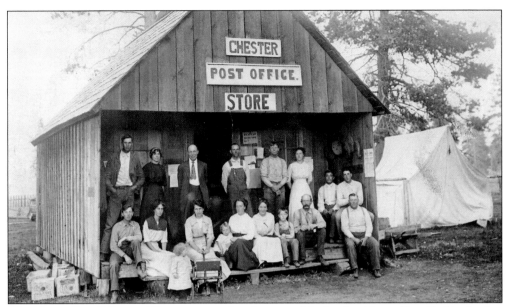

The Chester Post Office and Store is pictured with many of the local residents. Identified in the first row are Edith Martin (third from the left, with toddler Freda Olsen standing next to her stroller), Maude Gay (fourth from the right), Maude's son Randall (third from right), her cousin George Olsen (second from right), and Maude's brother Till Randall (far right). Standing in the second row are, from the left, Charley Lee; his wife, Minnie; and Nels Olsen. The rest are unidentified.

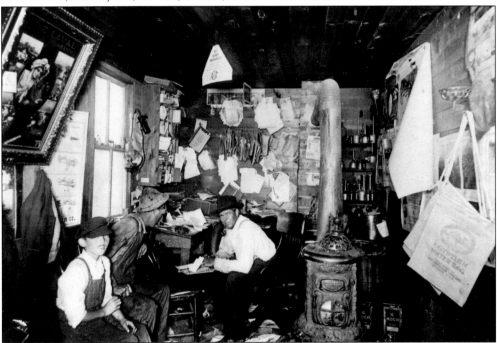

An interior photograph of the untidy little store has Maude's brother Till Randall sitting at her desk, with the open post office boxes on the wall above the desk. No wonder people sometimes felt that Maude read their mail before they had seen it. According to this photograph, it appears that there was a large demand for oilcans.

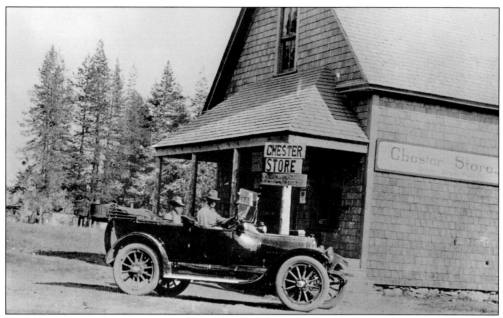

With the eminent flooding of the east side causing a shift in public services to the west side of Big Meadows, not to mention the insufficient space in Maude's first store, the Olsens built the first store in the Chester townsite on the corner of the Red Bluff Road (now Main Street) and the Prattville Road (First Avenue) in 1912. Maude's post office occupied one corner of the store before moving into its own building.

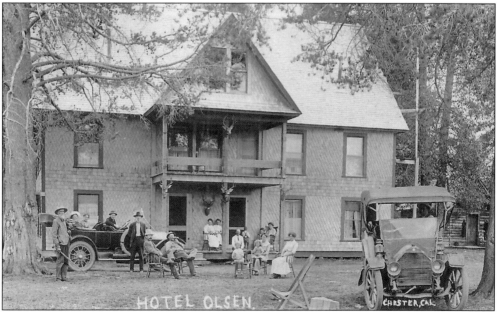

In 1913, Nels Olsen began construction of a hotel built across and attached to the front of the former ranch house, which became the kitchen wing. The Olsen Hotel, or Hotel Chester, opened in May 1914, just days before Lassen Peak erupted on May 30, 1914. Of course, Nels did a booming business that summer. He kept a running record of the volcano's activities in the hotel register, now in the Chester–Lake Almanor Museum.

The lobby of Hotel Chester sported examples of George Olsen's taxidermy skills. A large number of their guests were expected to be fishermen and hunters. The hanging wires were for electricity and phone service that were later additions to the building.

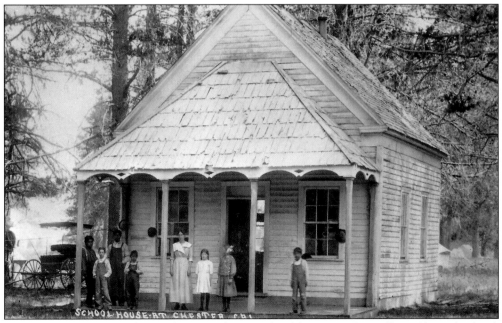

Annie Kelly was the teacher in this 1912 photograph of the Lassen Butte (later Chester) school. Boys like Randall Gay (second from the left) were required to remove their hats before entering. Note Kelly's buggy, which she drove down from her family's resort in Warner Valley each day.

Carrie *Randall* *Maude* *Grace*

Early settler Peter Olsen brought the skill of snowshoe making from his native Norway, teaching his sons to make and use these early longboard skis. Everyone in the family mastered their use.

This charming photograph shows Bill Olsen, little sister Freda, and cousin Randall Gay playing Indians. Randall appears to have a real gun, though it is probably not loaded. The Chester–Lake Almanor Museum has a small pair of beaded moccasins made for Freda by a local Maidu woman.

The Red Bluff-Susanville Wagon Road, as challenging as the Humboldt Road in places, is seen in this photograph taken near High Bridge. Highway 36 has supplanted the road, but an old section can be traveled by taking Wilson Lake Road through Feather River Meadows, Stump Ranch, and Domingo Springs.

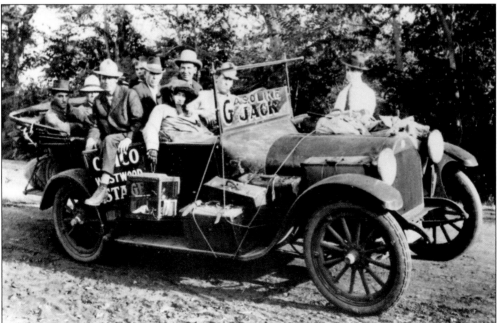

By 1913, the Red River Lumber Company was building the biggest lumber mill in the world as well as the town of Westwood, creating a huge demand for laborers. "Gasoline" Jack Houk ran an auto stage service between Chico and Westwood, helping to fill the demand for workers. A one-way ticket was $6, and a round-trip ticket was $11. It is unknown if the fare covered the bunny on the running board.

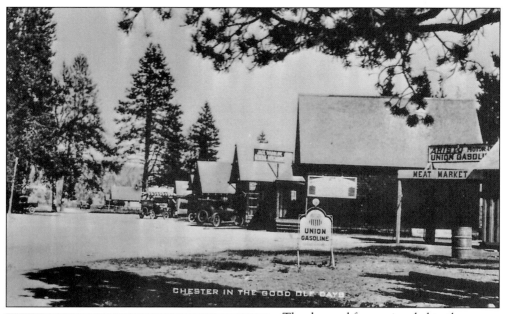

CHESTER IN THE GOOD OLE DAYS

nine foot Sugar Pine, Chester Cal.

The demand for services led to the growth of the town of Chester, seen in this 1925 postcard photograph. The Corner Store (now known as Old Town Corner Store) was then owned by Greenville native Jack Wardlow. In the foreground is a meat market and store operated by Harry "Jake" Stover, Thaddeus's son. Farther down the street is a striped awning at the Mt. Lassen Transit stage stop. They continue to carry the mail from Red Bluff to Chester to this day.

This photograph of Nels Olsen with a sugar pine is a portent of the change to come: the end of the dairy industry, followed by the rise of the large-scale timber industry.

Nine

GREAT WESTERN POWER COMPANY BUILDS A DAM

The early 1900s brought major changes to Big Meadows. Powerful timber interests had begun buying up timberlands in the township. The early sawmills of Johnny McBeth and Charley "C.H." Lawrence had supplied the construction needs of local residents. The expansion of railroads into the county meant that large mills could be built, with shipping now available for their huge output of lumber. The growth of large local dairies in the Central Valley and the implementation of stricter legal standards for the handling of milk and milk products had prompted many Big Meadows dairymen to either switch to beef cattle or leave the business entirely. Automobiles were the rage, and early models were beginning to find their way into Big Meadows.

Electricity had become the latest measure of progress, especially hydroelectric power. An enterprising civil engineer, Julius Howells, remembered a huge, well-watered meadow he had seen back in the early 1880s during an expedition organized by Prof. Alexander Agassiz of Harvard. Of the 11 rivers descending from the Sierras, the Feather River was the largest. The North Fork was the largest tributary to that system, generating the most hydraulic energy in its drop of 4,350 feet in the 74 miles between Big Meadows and Oroville. It was Howells's idea to dam the river at the end of Big Meadows, creating the largest man-made reservoir of the time. Such a project would demand a vast investment of money. Howells pitched his idea to two up-and-coming men of influence: Edwin and Guy Earl.

Edwin Earl was a newly wealthy Los Angeles newspaper owner who had patented a design for refrigerated railcars to ship fruit, vegetables, and other perishables. He made a fortune leasing his railroad cars. His brother Guy was an influential attorney in Oakland with social connections to San Francisco's wealthiest men. The Earls set about organizing a company, Western Power Company, and gathering the massive amounts of capital needed from investors. They selected Oakland real estate speculator/developer Arthur Breed for a most delicate mission: to obtain sales options on all the ranches in Big Meadows and, as Howells' plans took shape, Butt Valley. Breed was not to reveal anything about the plans for a hydroelectric system with Big Meadows as the key component; even his communications with the Earls were in code. People's curiosity was mollified with veiled references to a wealthy investor seeking to build a huge ranch, like the King Ranch in Texas.

What really gave Breed credence was the assistance given him by Augustus "Gus" Bidwell. Bidwell was the first Big Meadows landowner to sell to the power company, in 1901. He then partnered with Breed in gaining other owners' trust and getting options signed in 1901–1902 for 11,481 acres in Big Meadows and 3,139 acres in Butt Valley. It has been said that Bidwell did not know of the plans for

turning both valleys into huge water reservoirs, but that idea is highly questionable given the next steps taken. In April 1902, Howells arrived in Greenville, and he and Bidwell set out by wagon for Big Meadows, planning, as per law, on posting claims for water rights. They spent the night at Bunnell's, and the next morning, Bidwell learned that two strangers had stayed the night in Prattville, setting out early that morning for the steep river gorge leading to Seneca. Howells recalled seeing a man on his train from San Francisco wearing the high-topped, laced boots commonly worn by surveyors and engineers. He and Bidwell suspected the men were on the same mission, posting water rights. They drove to the projected dam site in the meadows and posted a claim on the North Fork for 2,500 feet per second of water "for milling, mining, manufacturing, irrigation, domestic purposes, and for the purpose of water power and the generation of electric power."

Howells and Bidwell then followed the river down about 1,000 feet, finding the two strangers nailing their water appropriation notice to a streamside tree. "You are too late, we've already posted our notice upstream from here," Howells told them. The law at the time, developed during Gold Rush days, would have granted the rights to Howells, but the strangers were undeterred, walking away after the nailing. Knowing that the two would be bound for Quincy to register their claim, Bidwell and Howells pulled the phone line down and pounded it in two with rocks to prevent contact with Quincy.

Gus Bidwell then lit out for Quincy, knowing both he and the strangers would not arrive until after dark. Howells, meanwhile, went on to Butt Valley to finish posting water claims. The race ended that night, when Bidwell finding the county recorder at his home, hustled the man over to the courthouse to file his claim at 8:25 p.m. on April 8, 1902. The strangers arrived at 9:15 p.m., losing the race for water rights by 40 minutes. It was later learned that the other two fellows were working for the heirs of G.P. Cornell of Greenville, who had drawn his own plan for developing hydroelectric power in Northern California.

In 1902, Western Power Company incorporated, and serious planning for the massive project began. By 1906, a group of Boston and New York financiers had formed a syndicate that capitalized the now "Great" Western Power Company to the tune of $25 million. Great Western Power Company acquired the Prattville and Bunnell hotels, in addition to Meadow View, which was renamed Nevis and used as a company headquarters. Bidwell was now director of operations; he would later advance to division superintendent.

Great Western Power Company had expanded its plans by 1906, enlarging the planned reservoir to the point it now needed to acquire the properties on the western side of the meadows, including the town of Prattville, whose citizens had thought they would have "lakeside" properties. The company was unsuccessful in acquiring all of Prattville and found the west-side ranchers, like the Moaks and Baccalas, unwilling to sell out.

On July 3, 1909, what was always the biggest annual celebration began in the meadow about a mile out of town with speeches, a community picnic, and a baseball game between the Greenville and Prattville teams. At some point during the game, a big billow of smoke rising above Prattville caught someone's attention. With shouts, folks stampeded back towards town, but by the time the fastest had reached the outskirts, it was apparent nearly the whole town was ablaze. With no hydrants or equipment, the town was doomed. It was only natural that Great Western Power was thought the culprit, but there was no proof. In the Chester–Lake Almanor Museum resides a teacher's hand bell. On it is a tag reading, "Taken from the Prattville School the day before Great Western Power Company burned the town about 1910." The writer of those words was Dr. Fred Davis, Great Western Power Company's doctor at the time, who was hired to run the company hospital at Canyon Dam.

The *Lassen Advocate* of November 3, 1911, reported, "Prattville is now almost a deserted village." Only one store remained, Rob Costar's, now back in the "old" building, one of a handful of structures left or rebuilt. As for the other foot-dragging landowners, Great Western simply went to court and forced the sales through condemnation proceedings. Reluctantly, ranchers surrendered. One canny young cattleman, Charlie Stover, finally sold in 1911, with the provision that he could lease back any of his former acreage that wasn't under water, for grazing. Stover's grazing rights were passed on through deeds to Dye Creek Cattle Company, allowing them to lease back part of the Stover Ranch from Great Western's successor company, Pacific Gas and Electric, up through the 1980s.

The river is seen here near the site of the Great Western Power Company Dam on the Feather River. The first plan called for a concrete dam, a series of arches across the narrows of the river before it dropped farther down the gorge in its run through Seneca to the Feather River Canyon.

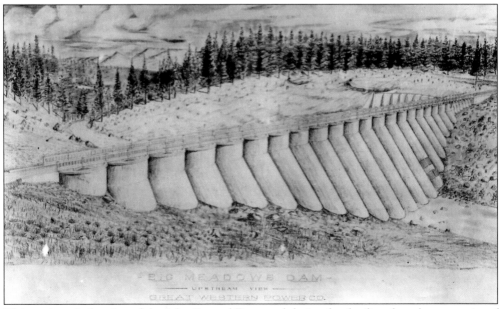

This engineer's drawing of the John Samuel Eastwood design for the first dam shows a series of concrete arches. When construction began in 1910, purchasing the materials was a challenge due to competition for supplies for the building of the Panama Canal and the rebuilding of San Francisco following the great 1906 earthquake.

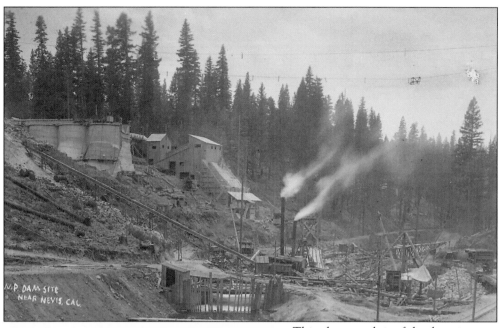

This photograph is of the dam site after three of the concrete arches had been completed. Behind the arches is the large rock crushing plant. Near the bottom of the image, the diversion channel can be seen.

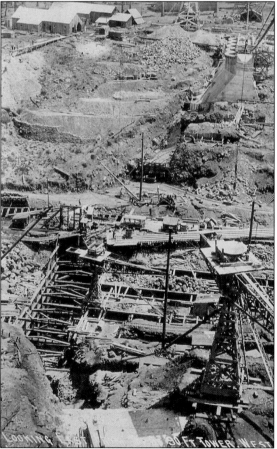

Five arches can be seen at top right in this 1912 photograph. It was at this point Great Western engineers discovered that they did not have the bedrock needed to build the next series of arches, and construction was halted until a new plan for an earth-filled dam was initiated. Panic set in downriver in Oroville and Marysville, both victimized by past Feather River floods. The State Railroad Commission was also involved due to the Western Pacific line up the Feather River Canyon, coincidently the major hauler of supplies to the project. During commission hearings, Guy Earl announced that the arch dam was being abandoned and a hydraulic-fill dam, using gravel, sand, and clay, would be built just upstream of the current site.

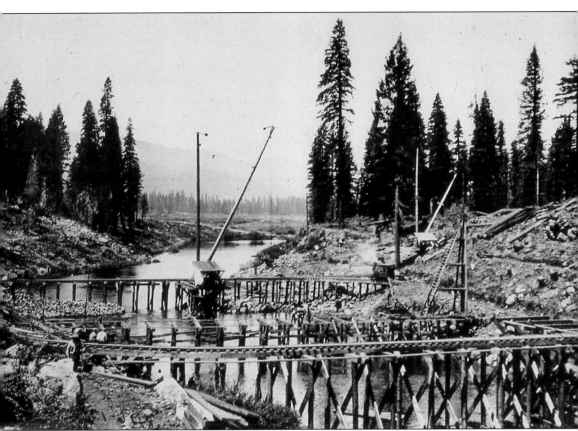

The new construction site for the earthen dam was just upstream (closer to the meadows) from the arches. A series of tracks would be laid across the site for the small dinky engine to deliver loads of rock and gravel. When those loads were up to track level, a flume would be erected, and huge water monitors would wash tons of clay soil in to settle on the gravel bed. The new dam, designed by Julius Howells, had a capacity of 220,000 acre-feet. It had a span of 650 feet from one canyon wall to the other. It was 85 feet wide at the crest, but 550 feet thick at its base. It rose 72 feet from the streambed to the crest. Flashboards were installed in 1916 to meet the demand for more storage. In the mid-1920s, a new, higher dam was added, just below and adjoining the original dam. The new dam was 1,200 feet across, 130 feet above the streambed, and 1,350 feet thick at the base. This increased water storage to 880,000 acre-feet. Water began to fill the west side, necessitating the building of a causeway for the Red River Railroad and the Red Bluff-Susanville Wagon Road. This dam had major work done intermittently by Pacific Gas & Electric from the 1930s through the 1970s to strengthen it and add storage capacity, now over 1,308,000 acre-feet. It was Julius Howells who coined the name for the new lake using parts of the names of Guy Earl's three young daughters, Alice, Martha, and Elinor.

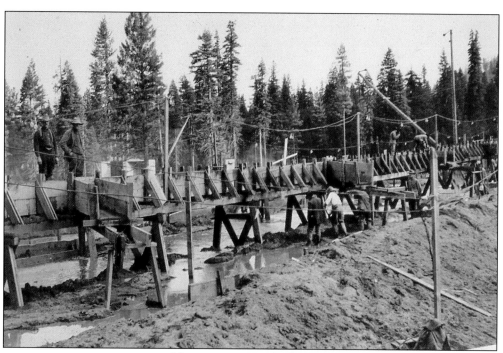

Here is an image of a flume showing open flume gates for delivering the wet soil. The water puddles on the top as the weight of the soil layers forces the water upward, allowing for compaction of the heavy soil and rock layers as the water evaporates.

BIG MEADOWS BASIN RAPIDLY FILLING

Rains and Melting Snow Caused Large Volume of Water to Collect in Reservoir.

Reports coming to Oroville state that the dam of the Great Western Power company at Big Meadows is occasioning the people of that vicinity no small amount of worry, now that the heavy rains have set in. The company had not planned to start to fill the reservoir before spring, but the heavy rains and the melting snow caused a large volume of water to collect in the reservoir, the flood gates of the dam not being able to take care of the flow.

The Nevis hotel is on an island, and the Big Springs are under water. The hotel had been deserted, so there was little damage.

On the Baccala place nearly 100 head of cattle are surrounded by the rising waters, and the owners are in a quandary about means for their removal. They will probably have to swim. An automobile is also marooned on the ranch. William Baccala nearly lost his life driving from the ranch with some of his effects when the water was seen to be rising rapidly. He managed to save himself, his team and his load.

The winter of 1913–1914 was a very wet one, causing the meadows to begin flooding before the power company and populace were prepared for it. This January 1914 article from the *Plumas National Bulletin* provides details of the resulting problems.

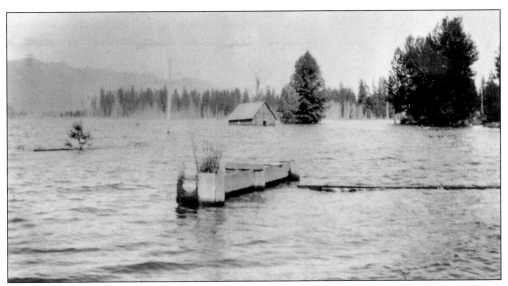

The dam was completed in early June 1914 after the meadows had already begun flooding due to a heavy winter. The Baccala Ranch at Big Meadows was one of the first to flood, as seen in this photograph of their barn. Some attributed the first modern-day eruption of Lassen Peak, on May 30, 1914, to this new dam; just as the 1975 earthquake near Oroville would be attributed to the much larger dam there.

An article from February 12, 1914, offers some sense of the urgency felt by Great Western Power Company and Red River Lumber Company. Floating logs were corralled and towed to the upper Hamilton Branch area, where they could be loaded onto railcars bound for the Westwood mill. A small power plant built to provide electricity to the Red River camp still exists at Hamilton Branch.

CUTTING TIMBER IN BIG MEADOWS BASIN

Report Reaches Oroville That G. W. P. Company's Dam Will Not Be Reared Higher This Summer.

OROVILLE, Feb. 10.—With little likelihood of the demand for power from the Great Western Power company materially increasing for some time after the completion of the two new units at the Big Bend power plant, it is not believed that the Big Meadows dam will be reared higher than it now is during the coming summer. This is the report that has been brought to Oroville during the past few days by one of the officials employed at the dam at the present time.

The dam has been raised to a height of 50 feet and now is practically completed at that height, although at any time the company desires it may be added to. Employes now are employed putting in rip-rap and spillways.

About 100 men are employed felling timber in the Big Meadows basin. There were 80,000,000 feet of lumber in the meadows and of this amount about 60,000,000 has been felled and brushed up. When the big reservoir is flooded the logs will float as the water rises and will then be taken to the spot where they are to be milled into lumber.

At points through the meadows there is from four to 20 feet of snow. At Nevis, the dam site, there is four feet. On the mountain sides on each side of the meadows the depth of the snow is considerably greater. When the spring thaw sets in it is believed that the meadows will be flooded in about two weeks with sufficient water to develop power at the Big Bend plant as soon as the two new units are ready. The lumberjacks are bending every effort to have the trees in the meadows cut down before the thaw sets in and the reservoir fills.

Soon, another problem developed, as roads in Big Meadows flooded prematurely, as detailed by an article in the *Plumas National Bulletin* of April 23, 1914.

The dam was completed in early June 1914. At the time, it was the largest earth-filled dam in the country, if not the world, but within a year, Great Western Power Company had to make plans to enlarge it. Work on the dam would go on intermittently until the 1970s. The construction of the reservoir not only benefitted the burgeoning hydroelectric movement in California, but also the political ambitions of the executives and the pocketbooks of its investors. The newly built Red River Lumber Company, in nearby Westwood, had contracted with Great Western Power Company for the timber rights, logging 300 million board feet of lumber before the dam was completed. For a few years afterwards, Red River Lumber Company barges plied the waters of the lake rounding up floating logs and loading them aboard railcars near Hamilton Branch. The Walker family and several Red River Lumber Company employees built lakefront cabins on Big Springs Road, as did company doctors Fred Davis and Herman Levin.

Alice, Martha, and Elinor (or Elinore) Earl, the daughters of Great Western Power Company founder and vice president Guy C. Earl, were the namesakes for the Almanor name, coined by visionary engineer Julius Howells.

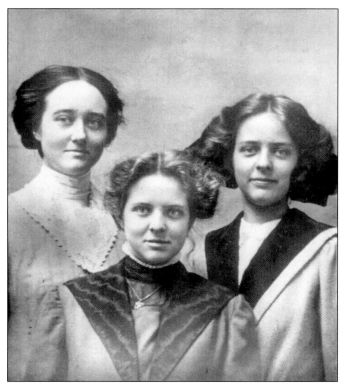

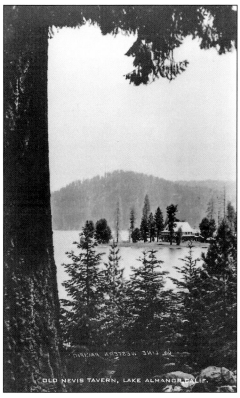

OLD NEVIS TAVERN, LAKE ALMANOR CALIF.

Meadow View, renamed Nevis by Great Western Power Company, was quickly surrounded by rising lake water that polluted the drinking water supply. Following the established company practice, it was burned. Some buildings escaped the torch due to the rapid filling of the meadows.

DISCOVER THOUSANDS OF LOCAL HISTORY BOOKS
FEATURING MILLIONS OF VINTAGE IMAGES

Arcadia Publishing, the leading local history publisher in the United States, is committed to making history accessible and meaningful through publishing books that celebrate and preserve the heritage of America's people and places.

Find more books like this at
www.arcadiapublishing.com

Search for your hometown history, your old stomping grounds, and even your favorite sports team.